TONY MAAN

Rembrandt's JESUS

Meditations on the Life of Christ

CRC Publications
Grand Rapids, Michigan

Rembrandt's Jesus: Meditations on the Life of Christ, © 1999, CRC Publications, 2850 Kalamazoo Avenue SE, Grand Rapids, MI 49560.

We welcome your comments. Call 1-800-333-8300 or e-mail us at editors@crcpublications.org.

Library of Congress Cataloging in Publication Data
Maan, Tony, 1960-
Rembrandt's Jesus: meditations on the life of Christ / Tony Maan.
 p. cm.
Includes bibliographical references.
ISBN 1-56212-402-1
 1. Jesus, Christ—Biography—Meditations. 2. Rembrandt Harmenszoon van Rijn, 1606-1669—Criticism and interpretation. 3. Jesus Christ—Art. I. Rembrandt Harmenszoon van Rijn, 1606-1669. II. Title.
BT299.2.M25 1999
232.9'01—dc21
 99-040242

10 9 8 7 6 5 4 3 2 1

With Grateful Heart . . .

This devotional is possible because of many people who were instrumental in the making of the book and the molding of my faith. Along with family and friends, spiritual mentors and teachers in my past too numerous to name, are these in particular:

Thanks to Janet Bron Greidanus, whose editorial input steadily maintained the delicate balance of honesty and encouragement simultaneously. And to Robert, Janet's husband, who helped me see the paintings with detailed clarity. And appreciation to the staff at CRC Publications.

To my parents, who introduced me to God and taught me the way of Christ, and to my four sisters.

To the congregations I have served, Brooks (Alberta) Christian Reformed Church and Bethel Christian Reformed Community Church of Edmonton. In their fellowship I experience the corporate presence of Jesus.

To my four children, who, in their own unique way, encourage and challenge me to live like Jesus in the comings and goings of daily life.

And affectionate thanks to MaryAnn, my wife, whose sharing in my life engages me to experience the beauty of God and the character of Christ more than words can describe.

Contents

Introduction

An old, forgotten family photograph found at the bottom of a neglected drawer can be the catalyst that leads to new places of discovery. It can prompt questions like, Who were these people? What was life like for them? How are they related to me? What does this tell me about my roots and who I am? Similarly, stumbling upon gems hidden in the treasure chest of history can stretch us to new places of faith. As we discover historical individuals and take some time to reflect on their thoughts, they open our eyes, our hearts, and our minds, expanding our vision of God's rule and our calling as citizens of God's kingdom on earth.

One such historical jewel is the seventeenth-century artist Rembrandt van Rijn (1606-1669), acknowledged by art history scholars as the Netherlands's greatest artist. Although his work was influenced by the age in which he lived, he transcended the social, political, and spiritual climate of his day. His paintings and etchings, dependent on his own experiences and spontaneous emotions, address the spiritual issues and universal questions that occupy all of humanity. In *The Golden Age of Dutch Painting* (p. 156), Barbara Rose writes:

> Rembrandt's paintings surpass those of his contemporaries, not only for their artistry, but because of their understanding and sympathy. Today, three hundred years after Rembrandt painted, we see him as the great individualist of art history. More than Michelangelo and Leonardo daVinci, more than Dürer and Grünewald, Rembrandt demonstrated independence from the taste of his age. At the same time, he

was the artist in whose work all of the characteristics of his age found the greatest synthesis.

Rembrandt's repertoire includes landscapes, still lifes, portraits, scenes of everyday Dutch life, and narratives of the Bible. He lived and worked at a time in history when the Renaissance and Reformation had awakened people to a quest for spiritual insight that would shed new light on their experience of life. The translation of the Bible into the current vernacular, along with the evolution of the printing press, had just begun to fuel and accommodate this growing desire. Rembrandt helped assuage the spiritual hunger by communicating to both the literate and the poorer, illiterate classes the experiential and divine truth of the Scriptures through his art.

A well-educated artist, Rembrandt was familiar, to the minutest detail, with the stories of the Bible. In his own way he was a preacher. He studied the biblical text, thought about the truth embedded there, and then proclaimed it through his gift of artistry. His portrayal was not merely a retelling of the story; it was also an interpretation and application of the story. In a widely accessible way, he wanted to communicate the authenticity and relevancy of the spiritual truth inherent in the text—and to do so in a fresh and relevant way.

Although Rembrandt's works include non-biblical and Old Testament subjects, our reflections in this book are limited to the artist's interpretation and portrayal of Jesus' earthly sojourn. As a believer and a master artist, he brings his own new light on the ministry, person, and teachings of Christ.

Today we are more fortunate than the largely illiterate population of seventeenth-century Europe. With our personal Bibles in hand, we are blessed with the ability to read. Rembrandt challenges us to read carefully. As we study the Word in light of the paintings, previously unnoticed nuances and insights spring to life, and our understanding of Jesus Christ is expanded. This artist's contribution to humanity can encourage us to grow in our knowledge of and relationship with the Lord.

Rembrandt used numerous artistic techniques in his paintings. He paid careful attention to body language, in particular facial expression and hand posture, often depicting characters reacting to a divine event intersecting the natural realm. With delightful and thought-provoking subtlety, he painted faces and hands that invite us to consider the dynamics of the inner, spiritual life. A clenched fist, folded hands, outstretched fingers, or hands resting strategically on another person reflect the painter's concentrated effort to express feelings often difficult to articulate in words. For example, the use of facial and hand expression figure prominently in *The Incredulity of St. Thomas*. And in *The Return of the Prodigal Son* Rembrandt uses a pair of hands to

communicate unique insight into the nature of God.

Rembrandt mastered the use of *chiaroscuro*, a word of Italian origin meaning "light and shadow." Through the artist's use of this method, the ordinary activities of daily life, which initially seem devoid of divine purpose, are transformed into moments filled with eternal significance. The paintings *Presentation in the Temple* and *Christ and the Woman Taken in Adultery* demonstrate this transforming power of contrasting light and dark.

Another practice the artist used was "self-portraiture," inserting himself into the very scene of Jesus' life that he was painting. For example, the helper holding a lighted torch in *Descent from the Cross* looks unmistakably like Rembrandt. This technique entices the viewer to become part of the scene; begin to question what point, or observation, the artist is making; and eventually start to wonder about the connection we ourselves have with the event being told. What position would I take if I were present at the scene? How would I be related to the others involved?

The Dutch master uses these techniques to bring us to a deeper understanding of the biblical story and its inherent faith lesson. Seymour Slive, a noted Rembrandt scholar, has observed, "Rembrandt's reputation rests on his power as a storyteller, his warm sympathy, and his ability to show the innermost feelings of the people he portrayed. Few artists match his genius for showing the human aspect of biblical characters."

Rembrandt serves as a gifted instrument, like a paintbrush in God's hand, enabling us to encounter the Jesus of the gospels. He helps remove some preconceptions and cultural practices that may obscure an authentic image of the man from Galilee. As we mature in our relationship with Jesus, we increasingly see with his heart and mind. The late Henri Nouwen wrote, "I know that I have to move from speaking about Jesus to letting him speak within me, from thinking about Jesus to letting him think within me, from acting for and with Jesus to letting him act through me. I know the only way for me to see the world is to see it through his eyes" ("Reflections: Classic and Contemporary Excerpts," p. 11). I believe the art of the Dutch master can help us realize these thoughts in our own lives. Ultimately, this book is not about Rembrandt van Rijn. It is about growing in our knowledge and communion with Jesus Christ. Whether you are a mature believer, a relatively new Christian, or an inquiring seeker, my prayer is that Rembrandt van Rijn's vision of Jesus Christ will help you know God more intimately and become like Jesus more consistently.

—Tony Maan

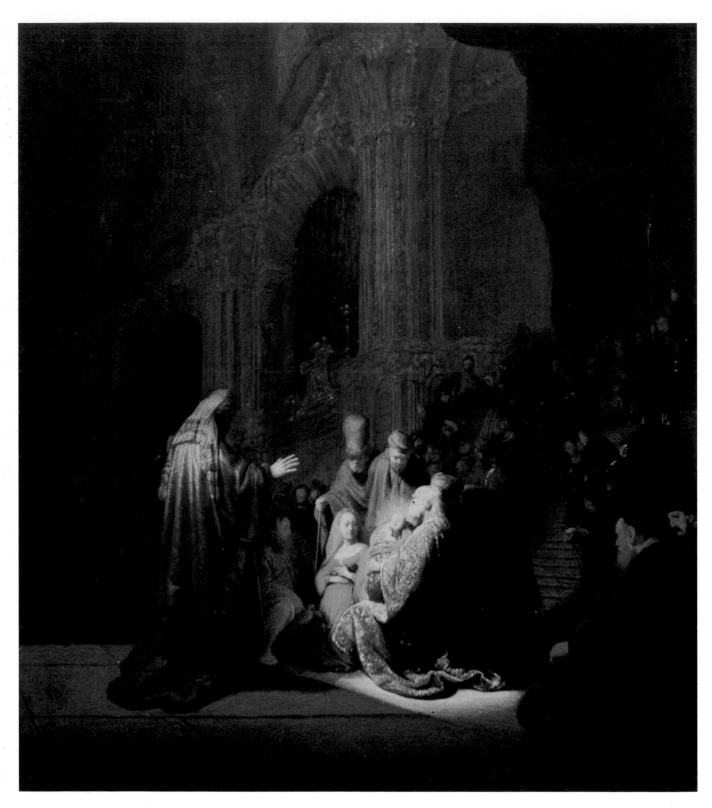

Presentation in the Temple ✌ Mauritshuis, The Hague, Holland/SuperStock ✌ circa 1631, 61cm x 48cm

Enlightening Dedication

AGreek ocean freighter, the *Amphion*, encountered storm trouble nine hundred kilometers off the coast of Newfoundland. As the ship was helplessly tossed to and fro by Atlantic waves three stories high, the anxious captain kept his ear to the radio and his eye on the horizon. Their SOS had been heard, and help was on the way. Time was the critical factor. The rescue team was racing against the same water the ship was rapidly taking in. Would they arrive in time? The captain kept his post on the bridge and watched. Then he saw it—a light on the horizon that told him the rescue fleet was almost there. All the crew members under his care would be safe! A huge weight had been lifted from his shoulders.

Simeon was called to watch the horizon of history, wait for the coming light of salvation, and announce its arrival. Luke records the day that happened:

On the eighth day, when it was time to circumcise him, he was named Jesus, the name the angel had given him before he had been conceived.

When the time of their purification according to the Law of Moses had been completed, Joseph and Mary took him to Jerusalem to present him to the Lord (as it is written in the Law of the Lord, "Every firstborn male is to be consecrated to the Lord") and to offer a sacrifice in keeping with what is said in the Law of the Lord: "a pair of doves or two young pigeons."

Now there was a man in Jerusalem called Simeon, who was righteous and devout. He was waiting for the consolation of Israel, and the Holy Spirit was upon him. It had been revealed to him by the Holy Spirit that he would not die before he had seen the Lord's

ℛ

Rembrandt . . . no doubt discussed the meaning of many passages with the preachers and scholars whose portraits he painted. . . . But in the end the Bible he illustrated was his Bible; that part of holy Writ which supported his convictions, those episodes that illustrated his own feelings about human life and of the divine intervention on which they depended.

—Kenneth Clark, *An Introduction to Rembrandt*, p. 117.

Christ. Moved by the Spirit, he went into the temple courts. When the parents brought the child Jesus to do for him what the custom of the Law required, Simeon took him in his arms and praised God, saying:

"Sovereign Lord, as you have promised, you now dismiss your servant in peace. For my eyes have seen your salvation, which you have prepared in the sight of all people, a light for revelation to the Gentiles and for glory to your people Israel."

The child's father and mother marveled at what was said about him. Then Simeon blessed them and said to Mary, his mother: "This child is destined to cause the falling and rising of many in Israel, and to be a sign that will be spoken against, so that the thoughts of many hearts will be revealed. And a sword will pierce your own soul too."

—Luke 2:21-35

After reading Luke's account, look closely at Rembrandt's painting. What can you tell about Rembrandt's interpretation of the passage? How does the painting enhance/change your understanding of the story?

Simeon had a burden, a calling placed in his heart by the Holy Spirit: he would not die until he had laid eyes on the Messiah, the One who would come to save Israel. Like a captain at the helm of a world in trouble, this elderly man knew that someone was coming to the rescue.

When he took Jesus in his arms, Simeon could see the light he had watched for on the horizon. His calling fulfilled, he could die in peace, knowing the world would be delivered.

Enlightening

As observers of Rembrandt's paintings, we benefit most when we read the text carefully and view the painting in the context of the story and the truth it bears. The artist was brought up on the Bible and, by the time he matured, had developed his own unique perspective on the stories of the Old and New Testaments. As he painted, he sought to express the spiritual realities and inner meanings of each particular passage.

In the painting *Presentation in the Temple,* Rembrandt sets the scene in the outer court of the temple. The central figures are the infant's parents, Mary and Joseph, the high priest, and Simeon, who holds the infant. The group is bathed in a light that seems to be coming through an opening in the roof. Rays of light illuminate the characters, with the most intense light resting on the faces of the baby Jesus and the elderly Simeon. The artist has portrayed this event in a moving way. Here an old man, near the end of his life, still hangs on, waiting for the hope and consolation of humanity. Now the day has reached fulfillment. In his arms he cradles the very child through whom he and his people will be consoled unto full redemption. As he holds the infant close to his breast, we feel the wonder

expressed in Simeon's face. He stares up to the light, mouth half open in speechless awe. His eyes are blinking at the brilliant light as though he were blind and is now seeing for the first time.

This painting captures the surprising moment of illumination. Like a moment frozen in time, it causes us to pause. Can you remember a time when you were unexpectedly enlightened with a new insight, an original thought, or a previously unknown revelation? You may be able to recall the time and place it happened. You "saw" a piece of life in a new light, like never before: the time you witnessed the birth of your first child; or the time you felt the indescribable presence of God with you; or the time you fell in love, right out of the blue! Such experiences stop you in your tracks and leave you lost for words.

The interrelated themes of light and sight are striking in this passage. The infant will be light for the Gentiles and will reveal the shining glory of God to Israel. And light is essential for seeing— without light we cannot see anything. Simeon sees and identifies the child for who he is. Using wordplay, Luke craftily incorporates the imagery of sight. Paraphrased, it sounds like this: "It had been revealed to Simeon that he would not *see* death before he had *seen* the Lord's Christ." Moments later Luke writes that Simeon, taking Jesus in his arms, says, "My *eyes* have *seen* your salvation, which you have prepared in the *sight* of all people." The italicized words are all rooted in

the same Greek word meaning "to see, catch sight of."

This theme was not lost on Rembrandt. He caught sight of Luke's intent and drew out the spiritual significance in the painting. The picture explores physical sight in relation to spiritual insight and the concept that as one ages and loses the ability to see clearly with the literal eye, one's vision of truth gains clarity. Rembrandt also created an etching of this scene in which Simeon's eyes are closed as he lifts the child up before the high priest. And immediately following the artist's death, friends found an unfinished painting of Simeon in his studio. This later painting depicts a close look into the face of the elderly man as he holds the infant Jesus.

The presentation of Jesus, then, was close to Rembrandt's heart, preeminent in his faith. In the dedication of Christ to God's will, the artist found consolation and eternal light in the face of death. Jesus was dedicated for enlightenment, for the artist and for us.

Divine Dedication

The call of Jesus is made apparent through Simeon's words of pronouncement: "For my eyes have seen your salvation, which you have prepared in the sight of all people, a light for revelation to the Gentiles and for glory to your people Israel" and "This child is destined to cause the falling and rising of many . . ." (Luke 2:30-32, 34). Jesus is the light of the world. Although the light in this painting appears to be coming from above, the artist simultaneously expresses the sense that light emanates from the infant—that the source of the illumination surrounding the baby and Simeon seems to be the child himself. He radiates light. Jesus' life will be dedicated to bringing light to the Gentiles and consolation and glory to Israel. He brings the very presence of God—love, grace, righteousness, and peace—to dwell among us.

Jesus did not seek the position. He did not decide to apply for the job. Rather, the role was given to him. The Father was at work in human history, preparing salvation for his people; and history was waiting for the key player in this plan to arrive and fulfill his place. An old man, in eager expectation and well-founded excitement, announced, "He is here!" Before the babe is old enough to know any different, he is given the role of Light-bearer.

The concept of *calling* played a prominent role in the mind and work of Rembrandt, probably because of his Calvinist upbringing. *Presentation in the Temple* conveys this Reformed emphasis that God's people have a calling, a preordained purpose. Like their leader, disciples of Jesus do not apply for the position. God calls us. We are irresistibly pulled to fulfill the calling—the ministry or mission he has prepared for us. Sure, we make a decision at some point. We choose to follow, or seem to. However, in retrospect we come to realize that the offer was too good to refuse—we couldn't have turned it down even if we had wanted to. God had designs on us before we

had any intimation of what our Father was up to. And now we're thankful he did!

Reflect on your own calling. What do you believe God has called you to do in the kingdom? How can we know what God calls us to do?

This method of God calling people in irresistible fashion goes against our individualistic tendencies. Yet God appears to know what he is doing. In his recording "Love and Life in Edmonton" (1995), Tony Campolo, author and speaker, tells the story about how he was called to dedicate his life to God. Parents, he begins, are God's way of calling us to commit to a life of service. He humors us with a story of his upbringing. As an Italian living in a predominantly Jewish neighborhood in Philadelphia, he quickly learned that Jewish people were called to be scholars while Italians were called to be food connoisseurs. How did he come to this conclusion? Well, each morning he would walk to school with his Jewish friend Albert Finklestein. Albert's mother would always ask, "Albert, do you have your books?" while Tony's mother would usually ask, "Tony, do you have your lunch?"

Campolo continues on a more serious note to explain that parents have a duty to announce—not encourage, or suggest, or hint at—but *announce* that their children have been put on this earth to serve God. Children born to Christian parents do not belong to themselves. They are not here to live for themselves. They belong, body

In his own calling, Rembrandt seemed to identify with the apostle Paul—so much so that, in his later years, he created a self-portrait in which he pictured himself as Paul. In the portrait, which now hangs in the Rijksmuseum in Amsterdam, Paul/Rembrandt is holding a manuscript near his heart, a sword subtly protruding from his cloak. The manuscript is presumably an epistle he has written and the sword probably refers to the sword of the Spirit, which is the Word of God (Eph. 6:17). This work of art persuasively suggests that Rembrandt believed he was divinely dedicated to bring the Word of life through his artistic labors.

and soul, to Jesus. They are to live for him by living for others. All sorts of other entities, like television, movies, magazines, and friends, are telling them what they should do with their lives; how they should dress, talk, walk, act, and eat. Shouldn't parents be doing the same?

For all who claim to be Christ-followers, this calling means pointing people to Jesus. The ultimate purpose of the divine call is not to be personally happy nor to be good citizens. It's not to set up programs, erect church buildings, or be successful in ministry. These may all be part of the equation, but the ultimate purpose of our call is to point people to Jesus, to show them the Light.

A Real, Dark World

Commitment to Christlikeness will also involve trials and unhappiness, as Simeon goes on to point out. "This child is destined to cause the falling and rising of many in Israel, and to be a sign that will be spoken against, so that the thoughts of many hearts will be revealed. And a sword will pierce your own soul too"(Luke 2:34-35). This call to live in full expression and obedience to the Father's will means inevitable conflict. Our lives will encounter resistance, turmoil, and heartache, because we live in a tragically fallen world. We live in a *real* world, and we live in a *dark* world. Being the light means dealing with the dark. This is the rest of the story. It makes the picture complete.

> *"Being the light means dealing with the dark." Give examples from your own experience that support the truth of that statement.*

The enlightened group in *Presentation in the Temple* is surrounded by shadows. Darkened figures are either looking at the child or occupied with other business—people with their own particular needs, personal agendas, suspicions, fears, and secrets. The two men peering over the shoulder of Mary, curiously observing the babe, are dressed as the poor were in Rembrandt's day. Their faces are filled with questions. There seems to be something special about this child, but what is it? Could he be the one who will release the impoverished? Old Testament prophecy was unequivocal in revealing God's compassion for the outcast and the poor. Perhaps the blessing Simeon utters over this child coins the infant as the one through whom God would act to bring blessed riches to the poor.

The high priest, an authority figure resplendent in red robe and headdress, stretches his hand out to give the blessing—this child to the glory of God! The priest's face, however, is darkened, signifying an ambiguity that will become public over time. As the infant grows and lives fully to the glory of God, the very hand that pronounced the blessing will be raised up in judgment and call for his crucifixion. The hand that now blesses, later points Jesus to the curse of the cross (Mark 14:63-64).

Along the lower right corner of the painting a rabbi is seated. Not bothering to get up, he views the spectacle from a reserved distance. He may be wondering at the lofty words Simeon has uttered. A child with such a role may forewarn of troubling interference in his own role as a religious leader in the community.

Mary is pictured looking on in reserved wonder, trying to absorb the words of Simeon about the child's destiny of causing many to rise and fall and the sword piercing her soul. Her hands cover her breast and womb, as if she senses the pain this child will cause her in the future. Mary too would experience a time in which she did not understand her son. And her eventual understanding would not ease the motherly sorrow she would experience as Jesus fulfilled his earthly mission.

Obedience to the call to follow Jesus is an exposing experience. Truth-bearing light exposes falsehood. All who encounter Jesus are compelled to make a decision—a decision with rising or falling implications, life and death results. He precipitates the central movement of a person's life, either towards or away from God. N. T. Wright, chaplain and author, writes, "There is more to Jesus than meets the eye. For me, studying Jesus in his historical context has been the most profoundly disturbing, enriching, and Christianizing activity of my life. As a historian, I meet a Jesus the church has unwittingly hushed up—a more believable Jesus, a Jesus who challenges me more deeply than any preacher, a Jesus

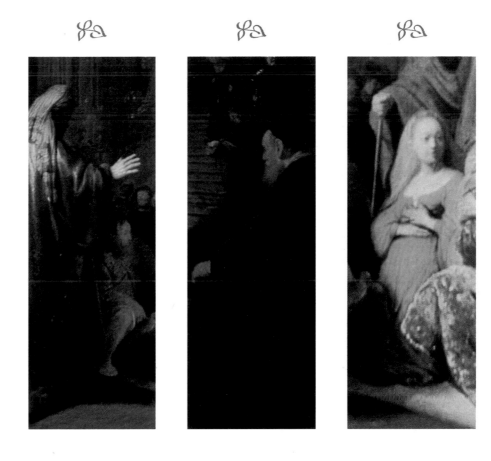

who evokes my love and worship by what he says and does. . . . We need to be grasped and transformed by the Jesus who was despised and rejected, belittled and battered" ("The New Improved Jesus," p. 26).

Once exposed to the down-to-earth light of Christ, we are transposed into light-bearers with him in a real world.

Spare the Specifics?

Rembrandt was gifted in expressing the "real life" quality of biblical scenes and characters. Our Lord was called into a world of places and people. People with names, feelings, opinions, faces, and faults. Settings that include priests, teachers, fathers, mothers, poor people, children, and old men. As a result, Christ did not live and speak *in general*. He does not come to save *in general*. As Christians, we may prefer to stick with the general principles. It is not as difficult when we focus on broader theoretical aspects—the vision, the direction, the principles of ministry, goals, and strategies. Although necessary for effective ministry, these things are not enough. Ministry in Jesus' name involves engaging people—people who may have bad breath or body odor, people with funny quirks and strange ideas or a history of mistakes. Service for Jesus is down-to-earth—being called to participate in the nitty-gritty. To love like Jesus means to love so specifically it may make us squirm with discomfort.

༄

Rembrandt had close association with the Reformed church in Holland throughout his life. His parents married in the Reformed Pieterskerk in Leiden. Rembrandt and his wife, Saskia, were married in the Reformed church in *Sint Annaparochie*, and their first three children were baptized in Reformed churches. When Saskia died, she was buried in the Reformed *Oude Kerk* in Amsterdam. Rembrandt's companion of later years, Hendrikje Stoffels, also belonged to the Reformed church, and their child, Cornelia, was baptized in the *Oude Kerk*. In 1669 the artist was buried in the Reformed Westerkerk in Amsterdam.

—H. Chapman Perry, *Rembrandt's Self-Portraits*, p. 107.

*How can we love people
we don't even like?*

In the movie *The American President*, the president of the United States had to decide to order an air strike on a civilian building housing a hidden intelligence center in a Middle Eastern city. He asked at what point of the day the least number of people occupied the building. His aids were not too concerned, saying that this is war and people die in war. Maybe so, said the president, but that does not change the truth that there will be a night janitor who kisses his wife and children goodnight, not realizing they will never see each other again.

Specific. A specific world with specific people. Such is the place where Jesus was called to bring the light of a real God. A world in which a Christian teacher still struggles with doubt in her faith after years of teaching. A place where a single woman, well-educated and attractive, remains single and lonely. A home where a father who has sought to be diligent, loving, and conscientious about passing his faith on to his children struggles with their rejection of Christianity. A world where a young husband, intensely in love with his wife, loses her in a car accident. Into such a place Jesus was called to live, to work, to heal and rescue, to love and to bring light. To this he was dedicated.

Rembrandt places the infant Jesus directly in the midst of our real world. The artist invites the viewer to see, with eyes

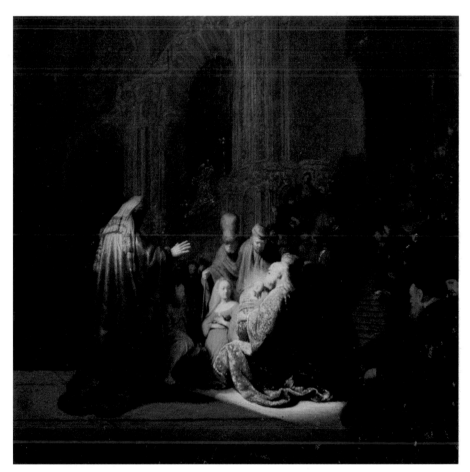

and with heart, the light Jesus brings through his faithful dedication to the cause of the Father. The artist also challenges us to follow as specifically in ministry as the Lord calls us.

A Real, Enlightened World

Norma Claypool is one inspiring example of a light-bearing disciple of Jesus in the overwhelming specifics of a worn world. Blind since she was two years old, sixty-seven-year-old Norma has discovered the calling to create a home for disabled children born with severe birth defects who would otherwise be homeless. In a house in Baltimore marked with a plaque on the front door that says, "As for me and my house, we will serve the Lord," she has become a mother to fifteen children over the course of the years. They include children like Jamon, who needed extensive reconstructive surgery for facial defects; Richard, who is blind; Sean, a four-year-old born with a hydrocephalic brain; Dawna, who is fifteen years old with a mental capacity of a two-year-old and whose favorite thing to eat is soap; and Evan, who has several afflictions, including cerebral palsy, hydrocephalus, seizure disorders, cortical blindness, and cognitive delays. Norma embraces these unwanted children. As one observer notes, "Norma Claypool's blindness shows forth the glory of God."

She's a little like a modern-day Simeon. With penetrating insight, Norma comments that her physical blindness takes nothing away from her vision of reality. Wittingly she says, "Believe me, I see a lot of things" (Marilyn Johnson, "What Happens to Children Nobody Wants?" p. 57).

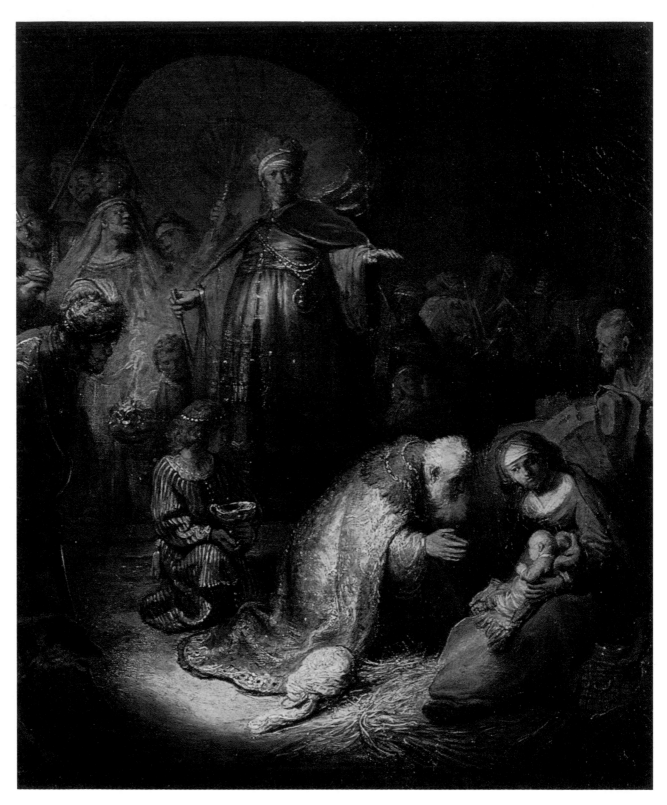

Adoration of the Magi 🙠 The Hermitage, Leningrad 🙠 circa 1632, 45cm x 39cm

Trembling Adoration

Masterpiece or fraud? Original or copy? Every newly discovered painting claiming to be an original has to answer to this scrutiny. Is this really a work from the hand of a master, or is it a copy done by a student? For several years *Adoration of the Magi* hung on display in the Gothenburg Art Museum in Sweden as an original. Meanwhile, under layers of dust, another "copy" rested in the storeroom of a museum in St. Petersburg, Russia. One day, an art historian took a closer look at the painting in St. Petersburg. After some analysis, he and others determined that the one in Sweden was actually a copy and the Russian one the masterpiece.

Matthew's account of the Magi coming to pay homage to the infant Jesus incorporates a similar test of authenticity in relation to kingship. In this story we seem to have two kings: the established Herod and the newborn Jesus. In fact only one of them is a real king; the other is fake. As the curators of the Gothenburg Museum discovered, things aren't always what they appear to be. Herod may look like the real McCoy, but looks can be deceiving! This is Matthew's version of the event:

After Jesus was born in Bethlehem in Judea, during the time of King Herod, Magi from the east came to Jerusalem and asked, "Where is the one who has been born king of the Jews? We saw his star in the east and have come to worship him."

When King Herod heard this he was disturbed, and all Jerusalem with him. When he had called together all the people's chief priests and teachers of the law, he asked them where the Christ was to be born. "In Bethlehem in Judea," they replied, "for this is what the prophet has written: 'But you, Bethlehem, in the land of Judah, are by no means least

❀

In the movie *The Last Emperor*, by Bernardo Bertolucci, an Asian dynasty had ended with revolution. The emperor's position had been replaced by a president who now held the power. However, the newly born heir to the emperorship was never informed of this fact. His mentors kept him confined in the palace and continued training him to occupy the throne. He had attendants who dressed him, bathed him, manicured and groomed him, taught him, and played with him. As he matured and attempted to exercise some real power, it quickly became obvious that all this training, ritual, pageantry, and protocol was void of any power at all. He was simply a figure, a symbol of an era gone by. As Matthew tells it, Herod's plight has unsettling similarities to that of the young emperor.

among the rulers of Judah; for out of you will come a ruler who will be the shepherd of my people Israel.'"

Then Herod called the Magi secretly and found out from them the exact time the star had appeared. He sent them to Bethlehem and said, "Go and make a careful search for the child. As soon as you find him, report to me, so that I too may go and worship him."

After they heard the king, they went on their way, and the star they had seen in the east went ahead of them until it stopped over the place where the child was. When they saw the star, they were overjoyed. On coming to the house, they saw the child with his mother Mary, and they opened their treasures and presented him with gifts of gold and of incense and of myrrh. And having been warned in a dream not to go back to Herod, they returned to their country by another route.

—Matthew 2:1-12

How can we recognize real authority? Who has it? How do we distinguish it from false authority?

Quest for the True King

Officially, Herod held the title "King of the Jews." Bestowed on him by the Roman government, this title gave him authority to keep a lid on those pesky Jews, who seemed to have minds of their own—minds not inclined to toe the line on things Roman. Herod had the delicate responsibility of keeping the Jews satis-

fied while making sure the emperor's feathers didn't get ruffled. To do so, he was given all the outward vestiges of earthly power: palace, throne, magistrates, and armies. At a casual glance he appears to be a king who is in control.

Further reflection uncovers quite a different picture. When Herod hears that some wise, informed men have traveled a long distance to worship a king of the Jews, and it isn't him, his insecurity is exposed. Their inquiry sets him off. "Get me the teachers! Who is this king they're looking for?" Before we can count the anxious beads of perspiration on his forehead, we see that Herod is running scared. A baby in diapers has him wondering if he really is the king.

In contrast to Herod, the gospel writer portrays Jesus. This stable-born child seems to be an unlikely candidate for a king. Yet the wise men say the stars are telling them a king has been born. The heavens announce the birth of the Christ—the promised, chosen Prince who is expected to bring peace to the world. The title "Christ" indicates the type of leader who will be a King to end all kings—the One and only Lord whose authoritative teaching and compassionate rule will inaugurate the kingdom of peace. The coming of Jesus into our world brings all of humanity the advent of pure justice and genuine grace.

Rembrandt's Portrayal of the Contrast

Take a few moments to study Rembrandt's painting of Matthew 2:1-12. At

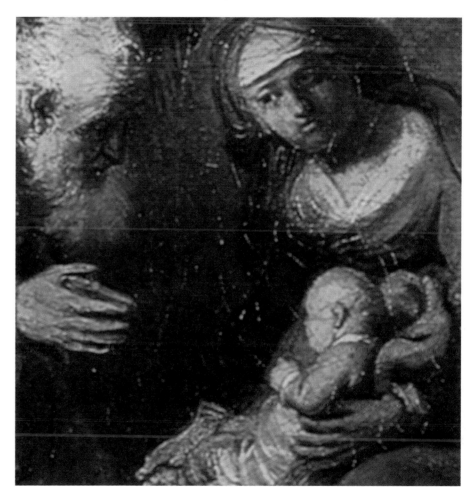

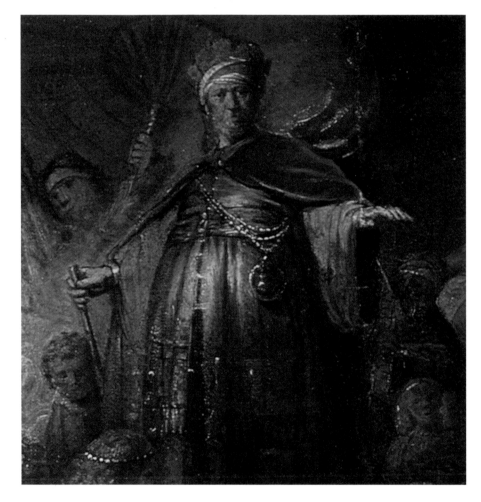

first glance, who catches your eye? Which character seems to be most imposing? Is it the large man standing upright with arms thrust out in the center of the painting? Staring right at us, he seems intent on taking center stage and holding our attention. Who is he? Let's postulate that this imposing individual is none other than Herod himself. "Hold on a minute," we want to interject, "according to the Bible and church history, Herod never got near Jesus! How could this character represent Herod?"

It's true that Herod never literally came this close to the child. But Rembrandt painted more than a literal view of the passage. His paintings are commentaries on the text. Rembrandt studied the gospel accounts and painted to communicate the action and the underlying dynamics at work in the stories. He sought to capture the atmosphere and the truths of the passage and express them through his art, just as a preacher does in a verbal way. The letter of the text tells us Herod never came near the infant; the spirit of the text is vibrant with the relational dynamics between Jesus and Herod. Rembrandt expressed this spirit in his painting.

Consider the upright figure in the picture. He stands central, a step above the baby and his mother. He has servants and soldiers surrounding him to attend his every need. To express his importance he strikes a royal pose with chest thrust forward. He keeps his gaze directly on the "camera" and entices the viewer to focus on him. His left hand is outstretched,

seeking to shield us from noticing the threesome in the bottom right corner of the picture: the child, mother, and adoring wise man. As we study the painting, however, the left hand of Herod actually serves to invite the viewer to focus on the group huddled in the corner. The light reflected from Herod's hand connects our vision with the light manifested around the holy family and the kneeling visitor. Rembrandt uses the light expertly to point to truth.

Bowed down in a posture that demonstrates humble wonder and awe is the well-traveled wise man. His balding head and remaining white hair suggest a wise, experienced, and aging individual. The Magi were believed to be exceptionally well-educated scholars, and this particular wise man is so knowledgable that he is able to acknowledge his own ignorance. As he ponders the eternal mysteries in the form of the baby, his slightly shaded face indicates his awareness of how much truth still eludes him. This man, and all the wealth of knowledge he represents, is brought to his knees in childlike awe. The hands of the adoring worshiper seem to tremble, as if desiring but not daring to reach out and touch the baby. He desires—the hands express the longing of the heart—to take hold of peace. He does not dare—such peace in a broken world seems too good to be true! Imagine the disappointment of peace promised but never realized. And yet, what is life without the hope this child brings?

Rembrandt's portrayal of the bowing wise man reveals that he recognizes the infant child as the authentic King. Only this type of king is able to bring us the shalom for which we wait. Apart from Jesus this rule of justice and peace is not possible. The most brilliant minds and most capable hands fall short of realizing such peaceful rule. The best political theories and most efficient social systems fail in their bid to bring complete harmony if attempted apart from the infant King. The genuflecting wise man has caught a glimpse of the potential for peace this child holds. Meanwhile, absorbed and discerning, he appears totally oblivious to the pretentious and attention-seeking presence of Herod.

Time to Respond

The Bible makes it clear that in the end we will all know who the real Ruler is. It also states that every person will ultimately acknowledge his lordship. Of course, before that happens there will be numerous counterfeits claiming access to the throne. And there will be countless voices expressing incredulity at the thought that the human Jesus, who never engaged in power-grabbing ventures or showed much muscle, could be considered anything close to a king. Nonetheless, from Genesis to Revelation, we hear it stated that Jesus is the Anointed One, chosen by God to be the definitive, peace-bringing King. The truth about this stable-birthed baby cannot be covered up forever. It will come to light. Inevitably! When all is said

৪৯

It is said that when the "Hallelujah Chorus" of Handel's *Messiah* was played for King George of England, he did something unprecedented for a king in those days: he stood up from his throne in utter amazement as the majestic power of the chorus filled the court. Rembrandt's painting of the Magi's trembling adoration viewed as strains of the "Hallelujah Chorus" play through our minds makes for a powerful proclamation of Jesus, our newborn King. Better yet, if you have Handel's *Messiah* on tape or CD, you might just want to listen to it while you ponder the painting.

and done, says the apostle John according to his vision, multitudes will stand before the throne of the Lamb singing, "Hallelujah! For our Lord God Almighty reigns. Let us rejoice and be glad and give him glory" (Rev. 19:6-7). What a vision! It's enough to make every heart that hurts for justice yearn with anticipation.

The day of full and public revelation that John saw is still to come. Yet, lack of such public revelation does not mean that Jesus doesn't reign today. He does. And his present-day rule calls for a response. Every figure in Rembrandt's *Adoration of the Magi* is forced to make some sort of decision regarding this baby cradled in Mary's arms. The expressions on their faces suggest penetrating thoughts as they mull over this pressing matter.

Look at each person in the painting. What can you tell from Rembrandt's portrayal about what these men and women have decided about Jesus? How do we recognize Jesus' present reign in our lives? How do we respond to it?

Matthew records a variety of responses to Jesus' birth. Most amusing is the response of the teachers of the law who advised Herod. For hundreds of years Israel had waited and longed painfully for the Messiah. Now some strange men come and announce that the day has arrived—the Messiah is here! How do these teachers react? They quote some Scripture, look at their watches, see that it's time to call it a day, turn off the lights,

and head home. Ho hum. Just another day at the office. Herod's reaction is much more animated. He sees red. A threat to his throne. Find out where this so-called "King of the Jews" is and let me know. The murder on his mind is cloaked by the pretense of worship. And finally the response of the Magi: Gentiles, foreigners from Persia, acknowledge this newborn King and desire to give him the honor due his name.

By virtue of hearing the news of the birth of God's Son, we too are compelled to decide one way or another about the claims of Jesus.

Which character in Matthew's account and/or Rembrandt's painting do you most identify with? Why?

An Atypical Ruler

In this painting, true strength is manifested not by the imposing Herod figure, but by the baby cradled in his mother's lap. Rembrandt's wise man is transfixed in humble admiration by the majesty of this vulnerable child. No question, Jesus is the "cosmic Christ" described in Colossians 1:15-20, whose sovereign rule directs the course of history.

In a world of ever-present evil and brokenness, we profess that nothing can separate us from God's love. All things *do* work together for the salvation of those who love their Lord. *How* does God bring this victorious rule into our experience? For our artist, such sovereign rule comes,

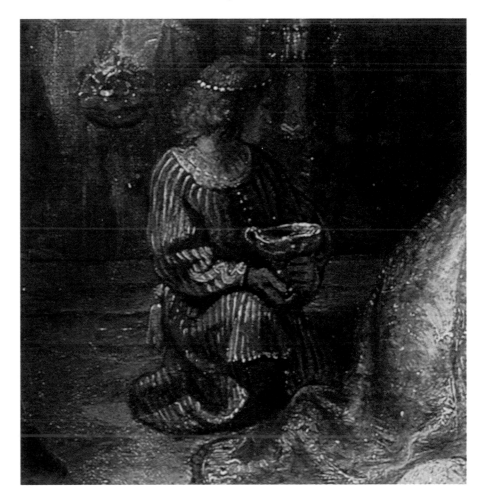

incredibly, through the advent and life-sacrifice of a humble Man who was sent by God. It is this angle of Christ's rule that Rembrandt emphasizes in much of his work, including *Adoration of the Magi.*

Harmenz van Rijn, Rembrandt's father, was the only member of his family to convert to the Protestant movement. In Rembrandt's childhood years Calvinist theology and church life played a substantial role in forming his faith. As the artist's educational path took him to new places, he was introduced to other faith perspectives, including that of the Mennonites. The Mennonite movement, initiated in the early 1500s in Switzerland as a wing of the Zwinglian Reformation, emphasized Christ's life of humble service, love, and obedience as the example for believers. Through such a life of Christlike giving, disciples manifest and enact the just and righteous rule of God on the earth. Christ-followers are royal priests—agents who rule by serving as avenues of God's grace to the world.

This idea of bringing the ministry of Jesus through sacrificial service had a significant impact on Rembrandt's view of Christ. Jesus' rule was quite different than the earthly power-mongering, fame-grabbing rule of the Herodian school.

God brought victorious change and redemption into people's lives through the humble servitude of those who sought to live like Jesus. This truth moved Rembrandt and is reflected prominently in the interpretation of Jesus' life and rule expressed in his works of art.

For us today, this means that Christ-followers are free to be fearless followers. Jesus won the victory over sin and death through sacrifice and resurrection while on earth the first time. We work and worship, serve and sing under the canopy of Jesus' lordship today. All is in his hands: the final outcome is sure. One day he will come a second time and make public for every eye and heart to see that Jesus, the Son of God whose birthday we celebrate every Christmas, is beyond doubt the true King. For now we make God's rule concrete in homes, schools, offices, businesses, and institutions by giving strength to the weak, hope to the hopeless, food to the hungry, and love to the lonely.

What does servant leadership look like? Who do you know that embodies this Christlike quality? How does he or she show it?

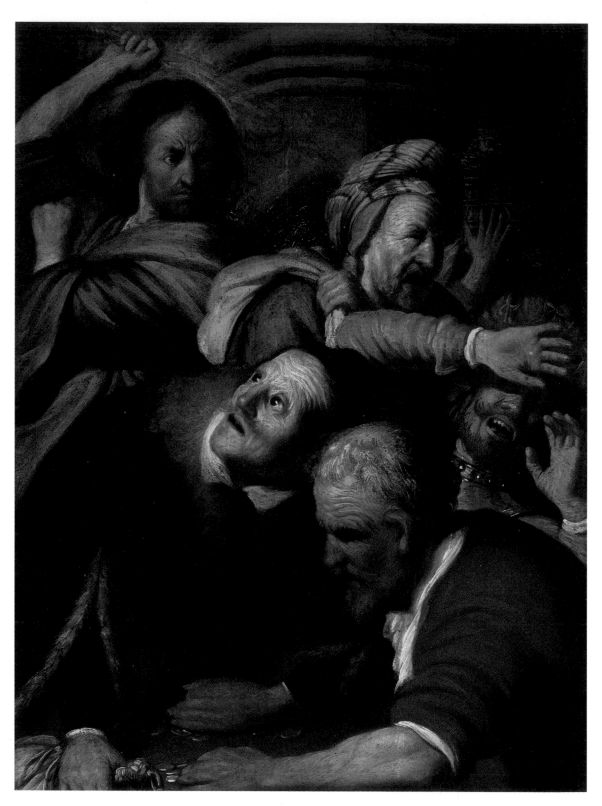

Christin Driving the Money Changers from the Temple ❧ Pushkin Museum of Fine Arts, Moscow, Russia. Scala/Art Resources ❧ circa 1626, 43cm x 33cm

Change

Sesquipedalian. It could be the name of a colorful, exotic creature living high in the trees of the Amazonian jungle. Or perhaps a rare cactus found only in the Australian outback. In fact, however, it is a word that fits comfortably into any conversation about church. Jesus' act of clearing of the temple is about church and change. The word *sesquipedalian* is bound to come up again, sooner or later, in our reflections.

The next day as they were leaving Bethany, Jesus was hungry. Seeing in the distance a fig tree in leaf, he went to find out if it had any fruit. When he reached it, he found nothing but leaves, because it was not the season for figs. Then he said to the tree, "May no one ever eat fruit from you again." And his disciples heard him say it.

On reaching Jerusalem, Jesus entered the temple area and began driving out those who were buying and selling there. He overturned the tables of the money changers and the benches of those selling doves, and would not allow anyone to carry merchandise through the temple courts. And as he taught them, he said, "Is it not written: 'My house will be called a house of prayer for all nations'? But you have made it 'a den of robbers.'"

The chief priests and the teachers of the law heard this and began looking for a way to kill him, for they feared him, because the whole crowd was amazed at his teaching.

When evening came, they went out of the city.

In the morning, as they went along, they saw the fig tree withered from the roots. Peter remembered and said to Jesus, "Rabbi, look! The fig tree you cursed has withered!"

"Have faith in God," Jesus answered. "I tell you the truth, if anyone says to this mountain, 'Go, throw yourself into the sea,' and does not doubt in his heart but believes that what

he says will happen, it will be done for him. Therefore I tell you, whatever you ask for in prayer, believe that you will receive it, and it will be yours. And when you stand praying, if you hold anything against anyone, forgive him, so that your Father in heaven may forgive you your sins."

—Mark 11:12-25

After reading the passage, study the painting. What can you tell about Rembrandt's interpretation of the story? What does Rembrandt help you see about Jesus? About the peoples' reactions to Jesus?

Christ Driving the Money Changers from the Temple
Corbis Bettmann circa 1635, 13.5cm x 16.5cm

Crowded Chaos

This is one of the few events recorded in the gospels where Jesus is very upset. His sudden burst of anger seems so human we could easily lose sight of his divinity. First he gets upset with a fig tree that does not provide fruit for his hungry stomach. Then, as if this has thrust him into a disagreeable mood, he vents his anger toward those just going about their business in the temple. As human beings, we all know what it's like to have anger get the best of us. Maybe Jesus was just having a bad day, like we all do once in a while.

Some people have claimed that the physical violence Jesus displays is an inappropriate and sinful response to anger. What do you think?

The painting *Christ Driving the Money Changers from the Temple* admirably cap-

tures the story of Mark's text. It portrays Jesus in expressly human terms. We can almost sense the fitful fire in the heart of the young painter as he seems to share in Christ's anger. The viewer is confronted with furrowed brow, scowling lips, raised arm, and clenched fist. Jesus is so close to us that we can see the whites of his eyes. The chaos of an angry outburst jumps out at us. The four merchants are placed close together. One is intent on collecting the last few coins before he retreats. Another looks at Jesus with surprise at the audacious boldness of the young teacher. Yet another has his loot over his shoulder, wondering whether he'll escape without a whack over the back. A fourth, about to be flattened by the rushing stampede, is protecting his face with his hands. Falling over one another, they fill up the entire canvas.

Some art critics have commented that from a technical point of view, this painting lacks harmony and perspective. But this lack may be an intentional ploy to reflect the dynamics of the event rather than the result of technical inexperience on the part of the artist (Rembrandt completed this work when he was only twenty years old). The merchants had lost spiritual perspective, at least according to Jesus. The actual event had little emotional or physical harmony.

Ten years later Rembrandt created an etching of the same incident (see p. 34). This time he chose to step back from the scene and include more characters. This later work communicates the utter chaos of the scene in the temple. Faces, created with minimal strokes, express intricate emotions: panic, bewilderment, haste, detached disdain, curiosity, and bemusement. In the tempestuous scene one individual is lunging to catch an escaping fowl, another man is being dragged by a startled cow, a dog is yapping at Jesus' heel, barrels are rolling, and tables are flying.

Method in Mayhem

A close look at the face of Christ in the painting reflects a specific kind of anger. This is not a fit of spasmodic rage—an uncontrolled temper tantrum. It is an anger fueled by divine purpose. In this event, a type of acted parable, Jesus is using the mayhem as his method of teaching a lesson about spiritual truth. His actions are geared to make a point—a point emphasized with an exclamation mark of righteous anger. Rembrandt understood this and conveyed it through the composed face of Jesus.

The etching exhibits Christ's dark and ominous face. Here the artist has employed the use of a halo rather than facial expression to show the purposeful nature of Christ's act. The radiance of the halo is not around Jesus' head, where it was usually placed in seventeenth-century art to represent divinity, but around the hands of Jesus, underscoring the truth that Christ's anger is purposeful, part of his divine mission.

Fig Trees and Temples

How does the artist know this? Only by careful reading of the passage. The gospel

Etching was an art form just being developed in the seventeenth century. Rembrandt produced hundreds of etchings, becoming one of the most accomplished, proficient etchers of his time. Because these works could be reproduced and distributed much more easily than paintings, in his day he was more popular for his etchings than his paintings.

writer, Mark, brackets the clearing of the temple with a peculiar encounter with a fig tree. This incident, also a dramatic parable, sets the cleansing of the temple in historical context. On his way into Jerusalem, a hungry Jesus went to a fig tree looking for some sustenance. The tree had no fruit on it, and Jesus cursed the tree. The next day, following the clearing of the temple, the disciples noticed that the cursed tree had withered.

We are told that it was not the season for figs, which raises the question of why the tree should be blamed simply for following the ordained pattern of seasons. But Jesus wasn't talking about trees. A fig tree was often used as a symbol for the people of Israel (see Isa. 65:22; Jer. 17:8; Ps. 1:3; 92:12; Luke 13:6; Matt. 3:10; Rom. 11:24). Jesus' point, in terms of faith and redemptive history, was that Israel should have been ready for the arrival of the Messiah "in season and out of season." Whether it is the "right" time or not, we are to be prepared for the coming of the kingdom through the Son. In the sense that Israel was not ready for the arrival of the Chosen One, they were lacking fruit.

Christ's indictment of the people erupts as he views the lack of fruit evident in the mercantile activities in the temple. God had called Israel to be the chosen people, a light to the Gentiles, the avenue through which God would bring blessing to the world (Gen. 12:1-3). They had not delivered on this call. Instead, the chosen people had ceased being productive and sought to live merely for their own satis-

faction—to receive the spiritual blessing of God's chosen and not share it with others.

This self-serving attitude, evidenced by the activities taking place in the house of God, had turned it into a den of robbers. The people received from God and kept for themselves. Christ is upset with the caretakers of God's home who have transformed it into a shopping mall for personal profit. Such activity excluded other nations who desired to come and fellowship with God.

In Mark 14:58 we're told that Jesus said that the temple would be demolished, and he would rebuild it in three days. He would create a new temple. Although many misunderstood what Jesus meant when he said this, we know that he was referring to his body. He would be crucified and come back to life in three days. He accomplished the forgiveness of sin and rose to conquer death and bring new life. The apostle Paul picks up on this body imagery when describing the nature of the church, "Now you are the body of Christ, and each one of you is a part of it" (1 Cor. 12:27). In this body we experience unprecedented fellowship with God. This body of Christ, the church, is now the new temple "of the living God" (2 Cor. 6:16).

Jesus would inaugurate a new era in which communion with God would not be restricted to temple precincts. Following the establishment of the new temple, people would worship God in spirit and in truth, not confined to a specific geographical area or certain building.

Wherever people would gather together in the name of Jesus, as few as two or three, they would experience the presence of God. And this body of Christ would include people of all nations and kinds— Gentiles, Jews, Indian, Chinese, Swedish, Brazilian, Italian, American, young, old, X-ers, Boomers, post-modern, pre-modern, yuppies, poor, sick, healthy, and wealthy. An endless variety of people, cultures, and languages, all united by one confession in one Lord.

How productive has the church been in making people of all nations and races one in Christ? Where do you see room for improvement?

Israel was not prepared to receive the Messiah. They were not ready to take the next step into communion with God that the Messiah would bring. The bustling barter and business hum that Jesus witnessed in the temple told him they were far from recognizing and accepting him as the Messiah. In a burst of righteous wrath Jesus addressed this issue. Major change was necessary if the people of God were to be faithful to their calling. With some imagination we might hear Jesus thinking: Change? So you want to hear the tinkle of silver change in your pockets, do you? I'll give you change, but not the monetary type. And *that* type of change always creates commotion.

&

Mark Galli tells the story of Catherine of Siena, an extraordinary prayer warrior who lived in the Middle Ages and who had the unusual opportunity of meeting Pope Gregory XI. You would think she would be in awe, or at least polite, in deference to the papal office. Instead, when they met, she told the pope the vices of his papal court "stank." (She was referring to the glittering pomp of the Avignon papacy, when church offices were sold to the highest bidder, and pope and cardinals and bishops sported silk and jewels, and their homes were trimmed with gold and ivory.) When the pope calmly asked Catherine how she, a recent visitor to Avignon, France, could possibly know about his odor, Catherine replied that she had smelled the stench while she was still in Siena, some 400 miles away.

—Mark Galli, "Saint Nasty," p. 28.

Rembrandt's art
seems to complement
Mark's view of
Christ, highlighting
the particularly
human features of
Jesus. His account
bears witness to
events that express
Christ's humanity. For
example, it is Mark
who tells us that
Jesus' family thought
he was out of his
mind (Mark 3:21),
that at one point a
disillusioned Jesus
could not do miracles
because the people
had no faith
(Mark 6:5), and that
he sighed with spirit-
ual fatigue when the
religious leaders
wanted a sign from
him (Mark 8:12).

Up Close and Personal

Mark's gospel account reveals a Jesus
who confronts us unabashedly. He is not
afraid to ask us outright, "Who do you say
I am?" (Mark 8:29). This is not a rhetori-
cal question. Jesus waits for us to answer
it. In other words, in the presence of Christ
we cannot remain spectators, content to
sit on the sidelines and cheer or watch
with disinterest. He will not allow us such
apathy or luxury. He can get irritated and
upset. He gets up close and personal.

Mark proclaims the answer to Jesus'
question through the lips of a Gentile sol-
dier while Jesus hangs on the cross:
"Surely this man was the Son of God"
(Mark 15:39). Such an answer carries life-
changing implications. Jesus enters our
lives and begins to upset the applecart.
The crowds who initially heard his teach-
ing and received his healing discovered
that he was more serious and demanding
than they had realized. In fact, Mark tells
us that after people got to know the seri-
ous changes Jesus was calling them to
make in their lives, they asked him to
leave the neighborhood (Mark 5:17).

Jesus extended these challenges to in-
stitutional entities as well. He was not
afraid to challenge the church and its
members to examine their communal life.
When change was necessary, he wasted no

time in making this clear. Rembrandt's
etching pictures the religious leaders in
the background, appearing unperturbed
by Christ's attack. They were not about to
be bullied by some loose cannon all fired
up over some merchants trying to make a
few dollars.

We Don't Like Change!

Question: How many Presbyterians
does it take to change a light bulb?
Answer: Eight. One to unscrew the
old and put in the new, and seven to
form a committee to study the proce-
dure.
Question: How many Mennonites
does it take to change a light bulb?
Answer: Five. One to unscrew the old
and put in the new, and four to
arrange a potluck meal for after it's
done.
Question: How many church board
members does it take to change a
light bulb?
Answer: "Change? What do you
mean, 'change'?"

Although such humor always exagger-
ates, it often carries within it a kernel of
truth. Human nature harbors an inner
resistance to change. Change causes dis-
comfort and can create confusion. Why
toy with the status quo? Change meddles
with things that have worked so far. Why
fix it if it isn't broken? Change threatens
our security, calling into question past
practices and suggesting we may have
been doing it wrong all these years. The

faces Rembrandt painted in *Christ Driving the Money Changers from the Temple* reflect abhorrence at the drastic change Jesus is calling for.

We like stability, constancy. Not only do we like it, we need it. We need the sun to come up in a regular way, to have predictable work hours, and to wake up each morning with the same spouse beside us. Church, and Sunday worship in particular, is an experience we expect to remain constant in our ever-changing society. On Sundays we affirm eternal, unchanging truths like, "I believe in God the Father Almighty. . . ." We sing rock-solid beliefs like "Amazing Grace, How Sweet the Sound." We need that. Permanence.

The opposite is no less true: we need change as much as we need things to stay the same. Some things need to stay the same; other things need to change. Rembrandt belonged to the Reformed church of the Netherlands, a church birthed in the crucible of tumultuous times. For people like John Huss, Martin Luther, John Calvin, and Menno Simons, advocating reform in the church was not optional. Commitment to God's Word necessitated change and nothing less. The artist was familiar with the need for continual transformation. For the church, and especially for a church born of reformation, ongoing change was incumbent.

Today the church is called to examine itself regularly. We are obligated to reflect on our character and our calling, asking whether we are still being faithful. The words of 2 Corinthians 13:5 continue to challenge us. "Examine yourself to see whether you are in the faith; test yourselves. Do you not realize that Christ Jesus is in you—unless, of course, you fail the test?"

How can we determine when worship and ministry should remain constant in our church or denomination and when change is important?

Spiritual Inventory

Jesus, the Head of the church, constantly challenges us to be contoured to his image. He wants his body to be spiritually fit—shaped in conformity to his heart. We may wonder at times at the discrepancy between the institutional church and the ministry of Jesus. How compatible are these? How compatible is our concept of Christ and the biblical picture of Christ? The Warner Sallman portrait of Jesus found in many church school classrooms may be imprinted on our mind—the gentle Jesus with flowing brown hair and beard, soft blue eyes gazing slightly upward. Tony Campolo bothers us with some provocative thoughts on our image of Jesus. "Our society has taken Jesus and recreated him in our own cultural image. When I hear Jesus being proclaimed from the television stations across the country, from pulpits hither and yon, he comes across not as the biblical Jesus, not as the Jesus described in the Bible, but as a white, Anglo-Saxon, Protestant Republican. We have, in fact, done something

ℰℬ

In the pit of personal crisis, Job rages
a prayer of frightening honesty:

Obliterate the day I was born.
Blank out the night I was conceived!
Let it be a black hole in space.
May God forget it ever happened.
Erase it from the books! . . .
Rip the date off the calendar,
delete it from the almanac. . . .
Why didn't I die at birth,
my first breath out of the womb my last?
Why were there arms to rock me,
and breasts for me to drink?
I could be resting in peace right now,
asleep forever, feeling no pain. . . .
My repose is shattered, my peace destroyed.
No rest for me, ever—death has invaded life.

—Eugene H. Peterson, *The Message: Job.*

terrible. God created us in his image, but we have decided to return the favor and create a God who is in our image" (*Exploring Faith and Discipleship*, p. 103).

Does the portrait of Jesus that Mark paints fit with our image? Does our congregation reflect the biblical portrait? In Jesus' day, the religious institution and leaders would have had to answer such questions in the negative. Rembrandt's etching of the scene depicts the discrepancy between religious entities and Jesus. In the background we see religious leaders on a higher plane. Their solemn looks of dismayed disapproval reflect their intent to kill Jesus (Mark 11:18). Obvious dissonance, even hostility, stirred between Jesus and the religious establishment of his day. Jesus and the leaders were not even on the same page when it came to what God was doing in the world.

Jesus angrily lamented that the temple had become a den of robbers. It had lost the glorious vision of its original call to be a place to commune with God and a light to the nations. William Willimon states bluntly in one of his chapel talks, "What we want is Sunday as a time of stability. Our ministers become managers of conventional definitions of reality; our liturgies, an embodiment of the establishment. There is the King on his throne; here we are, all in a line of bolted-down pews . . . we don't want prophets. We want ministers who are managers of consensus, temple functionaries who scurry around the altar on Sundays in a desperate attempt to keep the known world intact, reassuring us of

the eternal stability of the status quo" (*Preaching to Strangers*, pp. 96-97).

As told by Mark and painted by Rembrandt, Jesus disrupts such a concept of church. He confronts us with questions: Are we aware of and do we pray for persecuted Christians in China, Sudan, or other countries? Do we sacrifice any luxury at all to relieve the hunger pangs of the poor? Have we bought into the value system and lifestyles of our Western culture to the degree that people can't tell we are devoted to Christ? Have we used creation's resources with little thought of stewardly replenishment? Do I see the unchurched derelict or colleague who Jesus wants to reach through my witness? Is my church a place where the drug addict, the homosexual, the wealthy, the lonely, the poorly dressed, the over-dressed, the punk rocker, the skater, the pregnant teen, the nose-pierced prodigal can find God? Jesus does not want the church to be a place where nicely dressed thieves gather—stealing from God and hoarding for themselves.

How does Jesus' parable recorded in Luke 12:16-21 help us understand how we may be especially tempted to rob God today?

Signs of a Changing Church

Mark originally wrote to Gentile Christians in Rome suffering persecution. He wanted to encourage them in hardship and assure them of their inclusion in God's family, the new temple. So he tells the reader that Jesus called the temple a "house of prayer for all nations"—a place where they, Gentiles, could engage in prayerful fellowship with God. The church of Christ is to be a place where earnest prayer goes on. It is the home of God, where people from all walks of life gather in groups large or small to talk with God. Jesus was uncompromising and adamant on this point.

In fellowship with other believers we engage in heart-to-heart types of prayer, after the boldness of such praying saints as Job. Such prayers are not *sesquipedalian*. *Sesquipedalian* means "given to using long words," and Jesus warned against such prayers in Matthew 6:7. He had little patience for those who kept babbling on in public prayers, believing they would be heard because of their wordiness. No, the prayers of God's people have power to change lives and change the world. Jesus was matter-of-fact: "That's why I urge you to pray for absolutely everything, ranging from small to large. Include everything as you embrace this God-life, and you'll get God's everything. And when you assume the posture of prayer, remember that it's not all *asking*. If you have anything against someone, *forgive*—only then will your heavenly Father be inclined to also wipe your slate clean of sins" (Mark 11:23-25, *The Message*).

Such a church is to be "for all nations." The body of Christ consists of many parts. Its universality includes countless cultures and colors. The language it speaks, like the gospel, is to be understandable to

෫෫

Malcolm Boyd's blunt and jarring prayer was wrought
out of the turmoil of racial tension:

I got very mad at a white guy today, Lord, when he came out with all
the old clichés during a conversation we were having. He just sat there
with a grin on his face and started telling lies about Negroes. He never
raised his voice. He was always a gentleman, you know, very
respectable and proper, while he crucified Negroes. I felt the nails
driven into me, too. . . .

And the other day I got mad at a Negro. He was so ashamed of being
a Negro that he had stopped being human. When I reached out to him
for a human response he just burrowed farther inside his brown skin
and wouldn't come out. He smiled all the time too, Jesus, like a smiling
dead man, rotting behind his mask.

Malcolm Boyd, *Are You Running with Me, Jesus?*, p. 51

all—educated and uneducated, rich and poor, sophisticated and simple. It works hard at bringing down the barriers of race, prejudice, and class distinction that alienate and isolate. Like John, who borrowed and adapted the Greek word *logos* to explain who Jesus was, this church engages in the never-ending task of learning to speak the language of the culture in which it is placed so it can relate to those who have not yet heard about Christ. "Though I am free and belong to no man, I make myself a slave to everyone, to win as many as possible. To the Jews I became like a Jew, to win the Jews. . . . To the weak I became weak, to win the weak. I have become all things to all men so that by all possible means I might save some. I do all this for the sake of the gospel, that I may share in its blessings" (1 Cor. 9:19-20, 22-23).

The church Christ envisions is one that diligently works at the difficult but essential work of forgiveness. "If you hold anything against anyone, forgive him, so that your Father in heaven may forgive you your sins" (Mark 11:25). In the autumn of 1997 South Africa experienced something extraordinary. Under the leadership of Archbishop Desmond Tutu, the Truth and Reconciliation Commission was initiated. This commission held hearings of any who wanted to come forward to tell the truth—to reveal their crimes, to claim responsibility for their actions, to share their stories of hurt, pain, and injustice. In return, any who confessed were granted amnesty. Skeptics of the process were silenced as the proceedings took place. As

the truth was being told, as tears flowed, as people stood face to face with those who had perpetrated, as forgiveness was asked for and granted, healing happened. A nation torn by years of apartheid and ethnic tension experienced the power of the gospel to bring salvation. Here the church, by God's grace, was faithful to her calling as a house of prayer and a place of forgiveness for all people.

Uneasy

This was not an easy chapter to write, and you may have found it difficult to read. Given the subject matter, it may be appropriate that both reader and writer are left feeling somewhat uneasy. Many who have grown up under the nurturing, protective arm of the church community love the church. We want to protect it and come to her defense when she is attacked. For this very reason—his love for the church—Jesus calls us to engage in spiritual self-examination, always testing our selves against the standard of his ministry.

Rembrandt realized there was something very unsettling about the deliberate act of Jesus in the temple. His portrayal of the events seeks to create unease, just as Jesus did in the event itself. The artist may have intended more than this—that our unease lead to constructive reflection, and reflection lead to a renewed commitment to be the true temple Christ calls us to be.

What does your church have to change to be such a temple? What do you have to do personally?

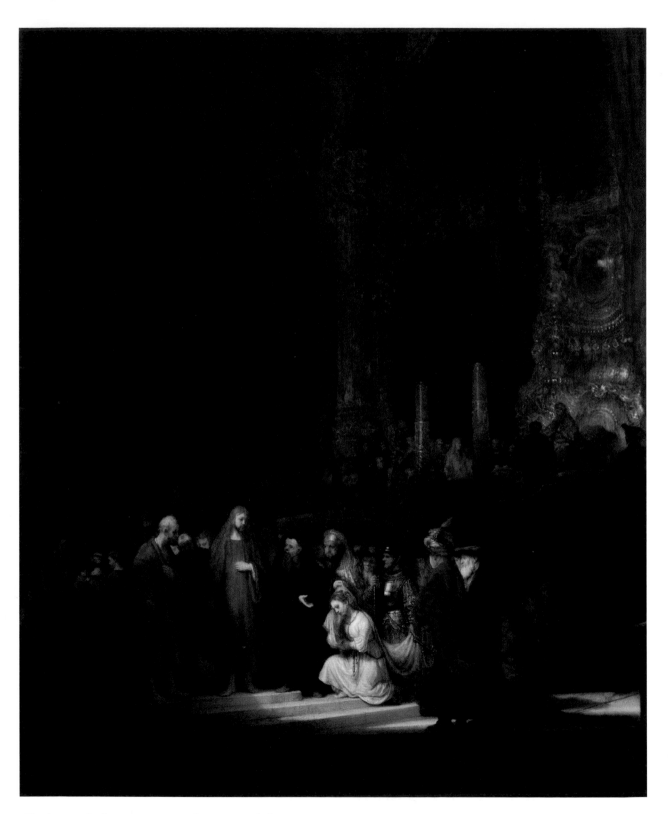

Christal and the Woman Taken in Adultery ℰ∂ circa 1644, 83cm x 64cm

Truth via Grace

In one of his "Dennis the Menace" cartoons, Hank Ketcham illustrates the complicated nature of truth through the eyes of a child. Dennis is standing defiantly on his chair, doing time in the corner for some misdemeanor. Complaining to his mother, he says, "If you're raisin' me right, how come I get into so much trouble?"

Truth is a big concept not easily defined. Jesus said we must become like children to know the truth of the kingdom. But that shouldn't dupe us into believing this truth is easily grasped.

The apostle John wrote to Greeks, a people who were passionate about knowing truth, a people who gave us truth-seekers such as Socrates, Plato, and Aristotle. So John tells them about truth that is more than a simple statement—truth expressed in a person. "I am the way and the truth and the life," Jesus said (John 14:6). Throughout the gospel of John the impact and implication of this statement is at issue. The episode of the woman taken in adultery drives us to grapple with the question of truth.

At dawn he appeared again in the temple courts, where all the people gathered around him, and he sat down to teach them. The teachers of the law and the Pharisees brought in a woman caught in adultery. They made her stand before the group and said to Jesus, "Teacher, this woman was caught in the act of adultery. In the Law Moses commanded us to stone such women. Now what do you say?" They were using this question as a trap, in order to have a basis for accusing him.

But Jesus bent down and started to write on the ground with his finger. When they kept on questioning him, he straightened up and said to them, "If any one of you is without sin,

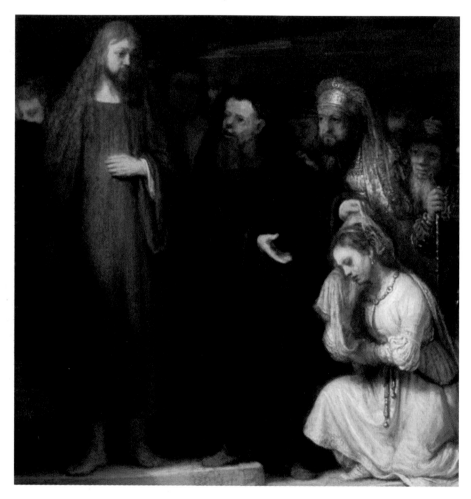

let him be the first to throw a stone at her." Again he stooped down and wrote on the ground.

At this, those who heard began to go away one at a time, the older ones first, until only Jesus was left, with the woman still standing there. Jesus straightened up and asked her, "Woman, where are they? Has no one condemned you?"

"No one, sir," she said.

"Then neither do I condemn you," Jesus declared. "Go now and leave your life of sin."

—John 8:2-11

Truth Quest

The courts of the temple were a common place for the discussion and discovery of truth. Here the rabbis and scribes taught their students. Here the religious leaders examined and interpreted the finer points of the law. Here also the high priest judged the cases brought before him—reflecting and pronouncing the truth in particular situations. The temple courts were a beehive of activity, all in quest of keeping law and order.

In this judicial setting, the truth became confined by rules and regulations. The Jewish people had 613 rules and codes pertaining to a wide variety of life situations. Developed over time and petrified into tradition, these codes became equivalent to divine truth: follow these ethical regulations, and you will know and live in the way of truth.

Something about this mentality appeals to us, doesn't it? It's straightforward. The boundaries are clearly defined.

The rules and expectations are clear and concise. Black and white with no gray areas. In fact, most of us probably grew up in homes where boundaries were established and defined by regulations. We were aware of household expectations, spoken or unspoken—that was OK, and this was not; one way was good, and the other way was not so good. And when we grew up and became parents ourselves, we discovered that this system was the best one going. Make the rules clear, tell the children it's for their own safety, and follow through with the detailed consequences when rules are broken. It's tried and true. We like it! And so did the scribes of Jesus' day.

Then Jesus showed up on the scene with the idea that we need to *live* the truth rather than simply define it. *Christ and the Woman Taken in Adultery* depicts two scenes of judgment taking place, contrasting the perception of Jesus' truth with that of the scribes. In the background the high priest is judging a person positioned between two pillars, a device the artist may have used to remind the viewer of the "pillars of truth" mentioned in 1 Timothy 3:15, where the apostle Paul addressed proper conduct in "the church of the living God, the pillar and foundation of the truth." The religious establishment of the day was called to uphold the truth and instruct people, so they conduct themselves accordingly. The high priest is going about this business.

The second group in the foreground points us to Jesus' idea of the truth. Here

૪ગ

While in prison, nineteenth-century Russian novelist Foyodor Dostoyevsky had time to read the New Testament and reassess the character and claims of Jesus. He writes, "I believe that there is nothing lovelier, deeper, more sympathetic, more rational, more manly and more perfect than the Savior. I say to myself with jealous love that there is no one else like him . . . there could be none. I would say even more: If anyone could prove to me that Christ is outside the truth and if the truth really did exclude Christ, I should prefer to stay with Christ and not with the truth."

—Fyodor Dostoyevsky, *The Letters of Fyodor Michailovitch Dostoyevsky to His Family and Friends*, p. 71.

a woman charged with a crime is brought forward, but in this case Jesus is asked to make a judgment. He is surrounded by a circle of disciples, religious leaders, and the woman accused. They are talking about the circumstances of her case. The scribes outline the evidence convicting her of adultery, explain the law of Moses on such a matter, and ask Jesus for his response.

Closely study the people in the painting. Think of who they are and what they stand for. Who are you most like in this painting? In what ways?

Quasi-Kangaroo Court

Exactly who is on trial here? A woman has been accused of adultery. In that day such a charge would have required virtually irrefutable evidence. Her accusers would have had to catch her in the physical act, and doing so would have required some planning. For some reason the religious leaders wanted to get rid of this woman, and it seems they were willing to frame her to do so. Admittedly she was guilty of the crime, but we may strongly suspect that the leaders had ulterior motives in charging her. To them, the woman was small fry. These authorities were going after the big fish—Jesus.

That's what's going on here: Jesus is being put on trial along with the woman. John tells us that the authorities questioned him "to trap him, in order to have a basis for accusing him" (John 8:6).

Their question—"Jesus, what would you do with her?"—sought to put Jesus between a rock and a hard place. No matter how Jesus responded, he would get into trouble. The Mosaic law prescribed stoning. The Roman law did not permit the Jews to judge and condemn on this matter. So if Jesus said, "Yes, stone her," he could be accused of treason against the Romans. If he said, "No, let her go," he would be perceived as being anti-Moses. In addition, if Jesus acquiesced to the stoning verdict, he would lose the sympathy of the people and be seen as harsh. Yet if he said the woman should be released, he might be perceived as a radical who rejected the traditions and wisdom of the forefathers.

The painting reflects these complicated dynamics. The artist observed the details of John's account and related them simultaneously. Central in the painting is the woman forced before the group. The lifted veil exposes the details of her position. An imaginary diagonal line, visible as the viewer's eye moves from Christ's hand to the Pharisee's hand to the kneeling figure, directs the focus to the woman as the ray of heavenly light highlights her. The eye falls on her and brings our mind to reflect on her predicament. Jesus stands quietly listening, his face showing concentrated attention on the woman and the unfolding dimensions of the scenario. The Pharisee's facial expression, forward posture, and outstretched hand express his question, What do you say? A man in the background holds an index finger to his

lips urging hushed silence. Shhhhh! Rembrandt catches the moment where Christ is on the verge of responding.

Jesus does not fall for the trap. He avoids the conundrum altogether and answers with neither a yes or a no. In fact, he turns the tables on these religious leaders: *They* are put under the microscope of their own judgment. He challenges them to scrutinize their own motives, examine their own hearts. He puts *them* on trial.

"If any one of you is without sin, let him be the first to throw a stone at her" (John 8:7). As the religious leaders ponder the challenge, they begin to leave, one by one, from the oldest to the youngest. Their heart search has exposed less than noble motives. They were not really interested in justice or in truth. Their incentive was the humiliation of this woman, their ultimate goal to trap Jesus in their crusade to get rid of him. They were using the codes of Moses to further their own political agenda and boost their own reputation as upholders of pure moral standards. They are, in the end, no less guilty than the woman—a different sin, perhaps, but no less serious in the eyes of God.

Jesus has confronted the religious leaders with a concept of truth that is not as definable as they had hoped. This truth is more about who Jesus is as a person than what he actually teaches. Knowing this truth means knowing Jesus, and it is impossible to know this truth apart from relationship with him.

ℨ

The technique of *chiaroscuro* was developed in Italy by an artist named Caravaggio (1571-1610). He was unique in breaking from the traditional Baroque style, introducing people who looked imperfectly human encountering God. He used light and dark to indicate this encounter. Rembrandt . . . eventually surpassed Caravaggio in the ability to use chiaroscuro to convey the presence of the Divine in everyday, ordinary scenes of life.

—Richard Rand, *The Raising of Lazarus*, p. 9.

As we connect with Jesus, we get in touch with ourselves. We realize who we are in relation to our Creator, ourselves, and the world we live in. Such a concept of truth does not necessarily exclude the presence of codes and rules. It encompasses them and goes beyond them. It exploits the blessing and divine purpose of such rules.

Our Truth Needs Grace

Jesus said to the woman, "Has no one condemned you? Then neither do I condemn you. Now go and leave your life of sin." The truth was that the woman had committed an immoral act and was living a life of sin. Her accusers were accurate in this regard, and Jesus does not dismiss this fact. However, Jesus seasons this truth with grace. Grace makes the truth bearable. Truth without grace means we're dead. The apostle Paul writes in Ephesians:

> *It wasn't so long ago that you were mired in that old stagnant life of sin. You let the world, which doesn't know the first thing about living, tell you how to live. You filled your lungs with polluted unbelief, and then exhaled disobedience. We all did it, all of us doing what we felt like doing, when we felt like doing it, all of us in the same boat. It's a wonder God didn't lose his temper and do away with the whole lot of us. Instead, immense in mercy and with an incredible love, he embraced us. He took our sin-dead lives and made us alive in Christ. He did all this on his own, with no help from us!*
> —Ephesians 2:1-9, *The Message*

Spiritually, apart from God we are without life. People may *appear* alive. We may have the lively mind of a scholar, the energetic body of an athlete, or the vivacious personality of a television star, but if we are not in relationship to Christ, we cannot respond to God. Like a corpse unable to respond to outer stimulation, we are unresponsive. Not 99 percent dead, but all the way dead. It becomes painfully obvious that we need God to intervene. God needs to make the first move—and does. God begins our redemption and completes it. This is *grace*. Amazing, unexpected grace—something the human mind or spirit could never really fabricate on its own. This idea of grace cannot originate anywhere else but from a divine being beyond the realm of human reason and imagination.

Describe a specific time in your life when you experienced God's grace. How did you respond?

Rembrandt articulates his perception of grace and other spiritual truth through the artistic technique of *chiaroscuro* (a combination of Italian words for light and dark). "Chiaroscuro served him as a means not merely of suggesting space but of expressing the depth of human character and religious experience. He used the intangible qualities of the visual world—

light, air, shadow—to evoke the mysteries of the mind and spirit" (Robert Wallace, *The World of Rembrandt*, p. 41). This method plays a significant role in *Christ and the Woman Taken in Adultery*.

Light and shadow portray the grace Jesus brings into the circumstances. The actual size of the work is 32½ by 25⅛ inches (83.5 by 64.4 centimeters). We can imagine how the looming dark area in the upper left corner would impress the viewer. It serves as a contrast to the brightness that illuminates the adulteress, who is bathed in the most light. At first the focus of that light almost seems like a mistake. After all, typically a painting that includes Christ features *him* as being lighter than the other characters. In such paintings the light actually seems to emanate from Jesus. However, in *Christ and the Woman Taken in Adultery* the illumination on the woman seems to come from somewhere else. Where or who is the source? We can imagine quite easily that it is God, the preeminent source of light. The woman is bathed in light, for she is the recipient of God's grace. And grace has transformed our vision of her: we see her not as the sinner deserving of death, but as a woman in the process of receiving God's unconditional grace through this encounter with Jesus.

Unnerving Grace

Some of us may be getting a little nervous with all this talk of grace. Talk like this makes us afraid we'll lose our nerve—our sense of control. Grace has a subtle way of infringing on our sense of equality.

How are you right with God?
Only by true faith in Jesus Christ.
Even though my conscience accuses me
of having grievously sinned against all God's commandments
and of never having kept any of them,
and even though I am still inclined toward all evil,
nevertheless,
without my deserving it at all,
out of sheer grace,
God grants and credits to me
the perfect satisfaction, righteousness, and holiness of Christ,
as if I had never sinned nor been a sinner,
as if I had been as perfectly obedient
as Christ was obedient for me.
All I need to do
is accept this gift of God with a believing heart.

—Heidelberg Catechism, Q&A 60

৪১

The main character of Victor Hugo's epic novel *Les Miserables*, Jean ValJean, exemplifies truthful grace. As a young man living in eighteenth-century France, ValJean was destitute and desperate. One night he stayed at a bishop's place and, before he left the next morning, stole some silverware. Caught by the police, he was brought back to the bishop. When the police asked the bishop whether the silverware belonged to him, the bishop replied, "Yes, but I gave it to him. Furthermore," he said, addressing Jean ValJean, "you forgot to take these candlesticks as well." Overwhelmed by the gesture of grace and unexpected kindness, ValJean became a changed man and decided to live the rest of his life for the God whom this bishop served. The novel tells the tale of his saving others in destitution, in particular a child, Cosette, whom he cared for after her mother died. At the end of the story, we find Jean ValJean on his deathbed. He says to Cosette, now a young woman, kneeling beside his bed: "I am leaving the two candlesticks on the mantelpiece to Cosette. They are made of silver, but to me they are pure gold. I don't know whether the person who gave them to me is pleased as he looks down on me from above. I have done my best." Exhaling his final breath, Jean ValJean "lay back with his head to the sky, and the light from the two candlesticks fell upon his face"—symbols of the grace that turned his life around.

The needle of our inner compass that consistently points us towards fairness is distracted by the magnetic pull of grace. It may not feel quite right. Frederick Buechner calls this unconditional grace "a crucial eccentricity of the Christian faith" (*Wishful Thinking*, p. 34), and Lewis Smedes says, "This is one amazing thing about grace, its surprising contradiction of the tender conscience" (*How Can It Be All Right When Everything Is All Wrong?*, p. 20).

But although grace is eccentric and contradictory to our conscience, we cannot live without it. As the apostle Paul makes so clear, we're dead without grace. Nor can we live without truth. Jesus said, "You will know the truth and the truth will set you free" (John 8:32). But can grace and truth coexist in harmony? At first glance, we may feel that they cannot: we're forced to choose one or the other—side with the Pharisees or side with Jesus. Either truth declares us guilty and we must pay the penalty; or grace comes along and lets us off the hook, nullifying the claims of truth.

But in this encounter Jesus demonstrates that it need not be one or the other—a showdown between truth and grace. He acknowledges the reality of a sinful world and teaches that we all need grace to live in such a world. We live in truth *and* grace. The word that expresses the complete harmony of these two entities, of course, is *love*. Divine love is uncompromising in truth and unconditional in grace.

We see this dynamic in the face of Christ as Rembrandt painted it. In getting to know Jesus, we also get to know the kind of love that holds a balance of truth and grace. That knowledge doesn't come overnight. It takes time—time to learn from him, live with him, and commune with him. And day by day, experience by experience, we grow into grace. We teach grace, we theologize about grace, we hear sermons on grace often. But *living* by grace—this is the tough part. Yet it does happen, gradually. The older religious leaders left the woman and Jesus first, John notes. It seems they had a little more life under their belt. They saw more quickly the truth of the circumstances.

As we grow, grace gradually infiltrates our hearts, our minds, our perspective on others. Then life is not primarily about a code of ethics. Grace has infused our knowledge of truth. We die by human truth; we live by divine truth. We live by Jesus. John Calvin said the best way to fulfill the law was to follow Jesus. Jesus' concept of truth turns out to be the complete, accurate, perfect expression of the very law the Pharisees promoted.

Think of some ways in which grace has infiltrated your heart, changing your perception of truth. How does the way you view truth now change the way you judge and treat others?

Thinking Gracefully Along the Way

Being a Christian involves much more than following a list of regulations. We have to use our heads to be faithful. We need to apply the life-giving matter of grace in our attempts to understand the truth about the world we live in and the lives we lead. Jesus said to the woman, "Go, and leave your life of sin." He didn't say, "See, they were all wrong about you. Live the way you please—God has no problem with it." No, Jesus recognized the apparent sin in her life. He next convicted her and her accusers of God's amazing, surprising grace. She was set free by it. And he called her to use that grace to live in the way of truth from that day onward.

Living in truth by grace didn't mean she would suddenly cease to be tempted to engage in illicit relations. But gradually, as grace took effect, life-changing transformation would begin to take place.

When we come across specific situations in our lives, a truthful grace response demands deliberation:

- A teenage pregnancy in the family initially makes a parent angry and ready to throw the book: live by the rules and your life would not be in such a mess! It may seem straightforward—the obvious truth. But does the grace-infused truth of Jesus call for a different response?
- Adultery is forbidden in God's law. We do our best to heed that law,

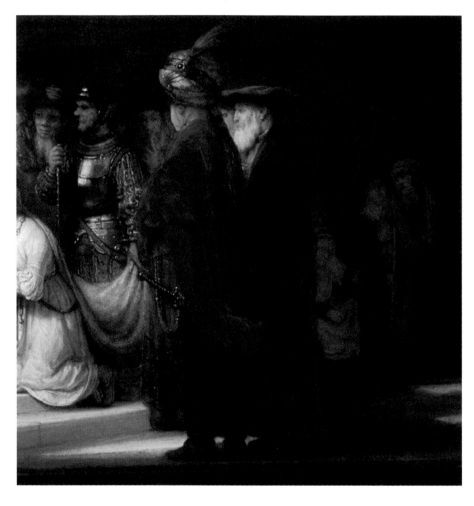

for adultery wrecks marriages. But how do we respond after adultery happens? A pharisaic mind says you call it quits on the relationship and never forgive. Living in the way of grace asks us to think hard about the words of Jesus: "You who have not sinned cast the first stone."

- A son who never learns to love his parents just for who they are makes a parent want to turn off the emotional tap and close down the relationship to the point of superficiality. A life touched by the grace of God calls for a different response—one that doesn't compromise on the truth or shortchange the miracle of unconditional grace.

Christlike responses to such situations leave us with no other choice but to think hard and fruitfully about the truth entrusted to us. We all fall short of God's perfect standard. We all have sinned. We all live by grace. The older we become the more we grow in awareness of this truth and the more we appreciate the grace we live by.

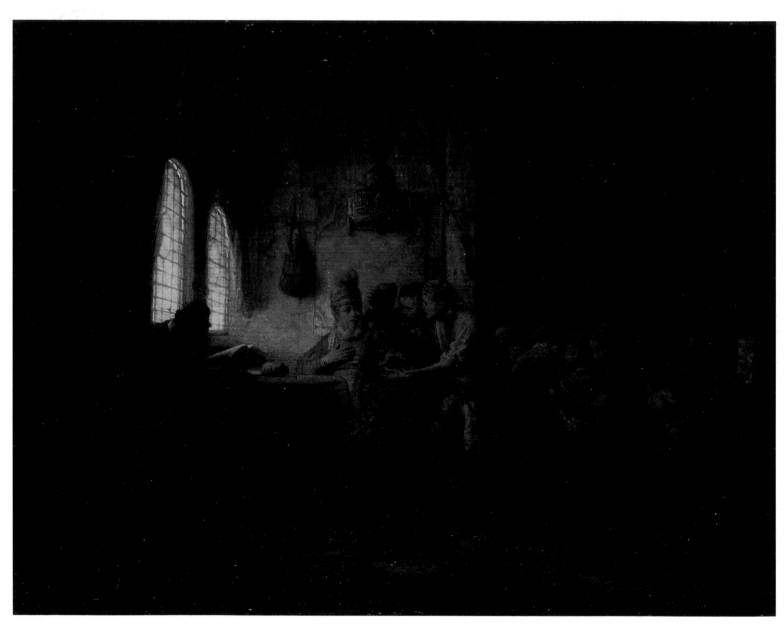

Laborers in the Vineyard ✌ Hermitage Museum, St. Petersburg, Russia/SuperStock ✌
circa 1637, 31cm x 42cm

Unfair Generosity

I t was the perfect situation for a seminary student—ideal for someone like me whose budget would not allow for a trip home for spring break. A local family had asked me to watch their house and pets while they went on vacation for the week. Their garage also needed a paint job, and I was game—for the right price, of course. We negotiated the remuneration—handsome for a starving student, I thought. The week was all planned: it should take two days maximum to paint the garage, and for the rest, watch the house, feed the cat, keep the canary company, watch a little TV (or a bit more than a little TV— after all, this was reading week!) and, of course, catch up on some studying. And get paid for it. You see? Perfect!

Well, it didn't turn out as perfectly as planned. Painting the garage took much longer than I expected. Upon the homeowner's return, I explained this significant detail. Yes, I hinted not so subtly, I had spent more time than expected in the hot sun with paintbrush in hand, hours gobbling up precious study time. Perhaps he would catch my intimation that the agreed-upon wage, generous as it was, might be increased in light of the unexpected labor required—me being a poor student and all. He looked at me with his pleasant, knowing grin, handed me the envelope, thanked me, and said he would be happy to employ my services in the future. The envelope contained the original, agreed-upon sum, no more, no less. Being the hard-nosed, direct, stick-up-for-myself type of guy I am, I didn't say a thing. Just mumbled "thank you," went back to campus, and sulked for a couple days.

The laborers Jesus depicts in his parable of the laborers in the vineyard were much more direct than I was. Once they sniffed out a perceived inequity in the workplace, they

immediately brought it to the attention of the boss. They were like good, solid union members who stood unapologetically for workers' rights—especially their own. Unlike me, they might have had a legitimate beef. Jesus tells the story:

For the kingdom of heaven is like a landowner who went out early in the morning to hire men to work in his vineyard. He agreed to pay them a denarius for the day and sent them into his vineyard.

About the third hour he went out and saw others standing in the marketplace doing nothing. He told them, "You also go and work in my vineyard, and I will pay you whatever is right." So they went.

He went out again about the sixth hour and the ninth hour and did the same thing. About the eleventh hour he went out and found still others standing around. He asked them, "Why have you been standing here all day long doing nothing?"

"Because no one has hired us," they answered.

He said to them, "You also go and work in my vineyard."

When evening came, the owner of the vineyard said to his foreman, "Call the workers and pay them their wages, beginning with the last ones hired and going on to the first."

The workers who were hired about the eleventh hour received a denarius.

So when those came who were hired first, they expected to receive more. But each one of them also received a denar-

ius. When they received it, they began to grumble against the landowner. "These men who were hired last worked only one hour," they said, "and you have made them equal to us who have borne the burden of the work and the heat of the day."

But he answered one of them, "Friend, I am not being unfair to you. Didn't you agree to work for a denarius? Take your pay and go. I want to give the man who was hired last the same as I gave you. Don't I have a right to do what I want with my own money? Or are you envious because I am generous?"

So the last will be first, and the first will be last.

—Matthew 20:1-16

After you have read the passage, take a close look at the painting. What can you discover about Rembrandt's interpretation of Jesus' parable? Who does he seem to sympathize with in the painting?

They Do Have a Point, Don't They?

Some art historians claim that Rembrandt sympathized with the workers in his interpretation of this story. The artist, they say, feels that the vociferous demands of the work-weary, sun-scorched laborers are wholly justified. Pay proportional to service seems like a perfectly reasonable demand. This painting was created in 1637 during a period in the history of Leiden that was marked with labor unrest. Workers in the textile industry, prominent in this part of Holland, began to organize. Budding labor unions developed as workers' rights became an issue, and people joined together to defend the well-being of lower-class employees. Such a cultural context was likely a factor in Rembrandt's understanding and portrayal of Jesus' story.

Rembrandt's depiction of this parable on canvas provides clues as to where his sympathies lie. We sense the tension in the air at the first glance. With the exception of the three workers rolling the cask of wine in the background, each character depicted is intensely involved in the dispute. The huddle of workers behind the two who bring the grievance are earnestly engaged in dialogue as they discover the wages they have received with respect to the time they have worked. To the right of the landowner sits the bookkeeper, pencil poised, crouched forward, leaning to hear the master's reply. The attentive expressions on the faces of the two complaining employees as they anxiously gaze upon the master, along with their coiled body postures, draw us into the dynamics of this scene. All of these characters compel us to reflect seriously on the burdensome matter at hand. The viewer cannot help but feel some sympathy for those who worked all day.

In the foreground is another clue to indicate Rembrandt's empathy for the workers. A cat has just pounced on a mouse. The Dutch used the saying "to live

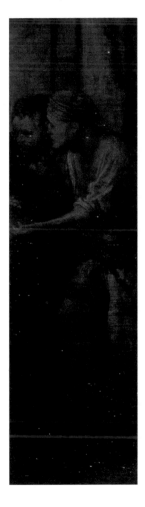

a cat-and-mouse life" to describe a life filled with tension, stress, and feeling like the underdog. Rembrandt, in his character and outlook, had a penchant for siding with the underdog. The downtrodden, those in the minority, the persecuted, and those who were discriminated against had a special place in his heart. Is the artist, then, defending the cause of the employees through his painting? They do seem to have a legitimate point.

If we interpret this parable today as an example of how an entrepreneur should run a business, we quickly run into trouble. Run a business the way the landowner of the vineyard did and you'd be bankrupt in no time at all! Employees catch on pretty quick—they would all show up at 4:00 p.m., work an hour, and expect a full day's wages.

Obviously, wages rendered need to be commensurate with work accomplished or there will be unrest among the forces. The hard realities of the market economy have not escaped Rembrandt's observant eye. However, we should not underestimate the carefulness of his study of the Bible. Further consideration of the painting uncovers the artist's comprehension of the parable's point.

Spiritual Arithmetic

A careful reading of the passage, in which we consider the details of the story itself as well as the context in which Matthew placed the parable, tells us that Jesus is talking about spiritual realities rather than commenting on business

practices. Although the Bible does instruct clearly on sound principles of good business and labor, such is not the case with the vineyard workers parable. This story concerns realities such as grace, service, and blessing, which are operative in our relationship with God.

Even so, we may have some difficulty in accepting the spiritual truths Jesus is communicating through this engaging story. Applied to our own situation, the action of the landowner may still raise our eyebrows. It just doesn't seem fair that the Master zealously hands out his gifts, willy-nilly and without discretion—no attention to length of service in his vineyard kingdom! Matthew places this story in the context of Peter's query, "Lord, what reward do we get for following you?" or, "What's in it for us?" Peter reminds Jesus that he and his fellow disciples have made some significant sacrifices. "What will our status be? Will we be at the head of the banquet table? We're important, right, Lord?"

Peter may sound arrogant, but don't we often seem to operate with the same logical scheme of spiritual dynamics? In our eyes, the more one serves in the kingdom, the more, or higher, one's status should be. Aren't God's eyes the same? Sure, those who come later will receive their reward. But according to the amount of time they've spent in the vineyard. Silently, we may subscribe to the "latercomer to faith, stay in your place" creed.

Prompted by an inner sense of fairness, we may be asking with Peter, "What about

Pastor and author Helmut Thielicke poignantly posed these questions: "What about those who squeeze through the gates of heaven at the last second? Those who grab the emergency brake of piety just before the fatal crash? All who enter the Kingdom in the dusk of their lives— these death-bed, last-minute believers?"

—Helmut Thielicke, *The Waiting Father*, p. 117.

those of us who slugged it out arduously, day in and day out, for years in the church? Will our status not be any different than theirs when all the record books are opened?"

"Don't worry, Peter, you'll get your reward." Jesus replied. "But remember, the first will be last, and the last will be first." The important, the first, in the eyes of the world—whether in the realm of popularity, or politics, or even religious structures—may well be last when the truth is fully revealed. Surprise, surprise! The least on the earth will be seated near the honorary head of the table. Jesus takes the earthly list of guests and flips it upside down. Without mincing words, he states, "I tell you the truth, the tax collectors and the prostitutes are entering the kingdom of God ahead of you" (Matt. 21:31).

Where is the logic? Where is the justice in that?

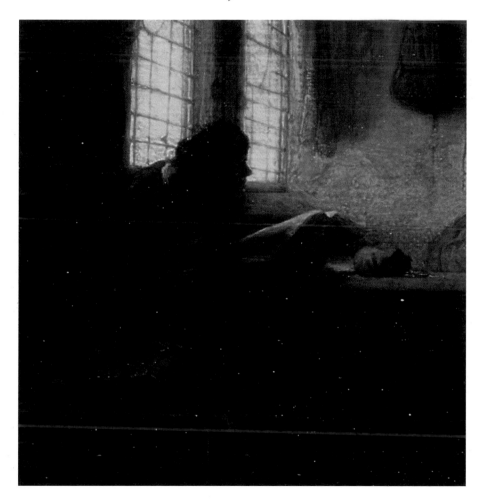

Evaluate your own assumptions about people you know who seem to be first in the church, in the denomination, or in God's kingdom. What questions does this parable raise about your assumptions? How do you react to Jesus' upside-down kingdom?

God's Extravagant Generosity

The logic and justice begin to become apparent when when we reflect on the words of the landowner. The boss replies to his complaining employees:

"Friend, I am not being unfair to you. Didn't you agree to work for a denarius? Take your pay and go. I want to give the man who was hired last the same as I gave you. Don't I have the right to do what I want with my own money? Or are you envious because I am generous?"
—Matthew 20:13-15

These words are key to uncovering the point of the parable. The biblically literate artist may have interpreted the parable more accurately than we first suspected. Rembrandt was familiar with the most minute details of Bible stories. His portrayal of these narratives expressed not only the external details but also his penetrating insight into their inner meaning. As we have recognized, the laborers are presented in a compelling way. And rightly so. Rembrandt appreciated the tense dynamics that usually accompany labor negotiating sessions. The illustration captures this environment. Yet in the heat of the moment, Rembrandt did not lose the point Jesus is making—the point that rests on the central character in the painting, the landowner.

The landowner sits squarely in the middle of the scene. The artist has caught the moment in the story when the master is speaking. His informative, authoritative word is being heard. The sunlight streaming in through the window illuminates him. Light represents truth. Rembrandt is showing us that this is a man of truthful authority. He seems unflustered by the onslaught of the gravamen. He appears fully in control of the circumstances. His position in the painting and his body posture serve to express his response.

The landowner's hands, in particular, are important. Rembrandt believed hands were vehicles of communication; they expressed one's inner feelings and thoughts. The right hand is over the man's chest. It brings attention to the heart—a tender, giving heart. A big man with a big heart. The other hand is extended. It extends towards the money in the servant's hand, and it extends towards the workers. These gestures reveal the spiritual realities at work in the story. Although the workers are subordinate to him in social terms, the landowner views them as equal fellow human beings.

The face of the landowner masterfully captures the mixed emotions he experiences at the request of the laborers. We detect a hint of surprise. He is wondering, "I'm just being generous. Why would anyone have a problem with that?" The face also communicates joy-filled glee—a contented, well-established delight in being generous. This man is not just interested in being fair. He is not merely interested in the equity of one day's wages for one day's work. It turns out that he wants to go way beyond that. He is into giving. Extravagant giving! A denarius, the equivalent of about two hundred dollars, was a very good wage for one day's work in Jesus' day. The owner goes to the marketplace, sees the unemployed, knows their need, and responds. In those days there was no unemployment insurance or other

social safety net. No work meant no food—either for the breadwinner or his wife and children. One hour's wages was pitifully small—not enough to provide for a family. So the vineyard owner takes pity on these men—every last one of them and their families. Why should we have a problem with that?

With whom do you personally identify in this parable? Why?

No Service Strings Attached

In *Parables of Judgment,* Robert Farrar Capon uses the fitting imagery of an accounting book to draw out Jesus' message. If we insist on going by the book, Capon says, we're all sunk from the first numerical entry. In the ledger of life we all come out in the red. We all owe more than we can earn or ever hope to pay. The good news is that God is not stuck on accounting books. He is interested in one Book, the Book of Life. Our name written there means we have life eternal. It doesn't matter whether our names were written there fifty years ago, today, or next year. Whoever we are and whenever it happens, our written name testifies to an autonomously gracious Master writer. It really, really has nothing to do with how long or short we've worked.

Is that fair? Not really. Thankfully for us, it isn't fair. If we went "by the book," none of us would find our names written there. God's generosity is unfair in that sense. God treats us not according to what

Pastor Robert DeMoor, in a lesson on this parable, illustrates the message with an example from his own childhood:

"Back in Ontario when the apples ripened, Mom would sit all seven of us down, Dad included, with pans and paring knives until the mountain of fruit was reduced to neat rows of filled canned jars on the basement shelf. She never bothered keeping track of how many we did, though we younger ones undoubtedly proved to be more a nuisance than a help: cut fingers, squabbles over who got what pan, apple core fights. But regardless of our output, the reward for everyone was always the same: the largest chocolate-dipped cone money could buy. A stickler might argue that it wasn't fair, since the older ones actually peeled apples. But I can't remember anyone ever complaining about it. A family understands that it operates under a different set of norms than a courtroom does. In fact, when my younger brother had to make do with a popsicle because the store ran out of ice cream, we all felt sorry for him despite his lack of productivity (he'd eaten all the apples he'd peeled that day—both of them)."

—Robert De Moor, "Who Deserves the Kingdom?"

we deserve, but according to the desires of his magnanimous heart. Luther wrote that God deals with us not according to our deeds and works but according to his grace and goodness.

This truth brings a whole new meaning to the business of everyday life. The sense of light in Rembrandt's painting, representing God's omnipresent grace, sets the tone of the workplace. The vineyard storehouse is permeated with the infectious generosity of the master. In spite of the weightiness of the complaining employees, the light streaming in through the window and coming to rest on the master as he explains his generosity creates a positive atmosphere. We sense a workplace encompassing purposeful busyness, industrious joy, healthy progress, and grace-infiltrated business management.

How privileged we are to be workers in the vineyard of the kingdom! In the kingdom community we experience the Master's benevolence. Through corporate worship, group Bible study, opportunities to share and pray, times of teaching and learning, and occasions to serve we taste the Lord's generosity. The good news of God's love we hear and experience in church life develops our faith perspective for all of life. We come to realize that some things in life cannot be earned or bought—things like beauty, peace and shalom, love, genuine friendship, and heart-touching community. All these are gracious gifts. They may be intangible in the visible or physical sense, but they are no less real in our experience.

Kingdom workers not only experience such gifts—they also express them. We dream a noble thing for God and work until it comes to fulfillment. It may be standing as a Christian politician, teaching a church school class, serving as a missionary, providing relief for the unemployed or a home of refuge for troubled youth, being a homemaker diligent in creating and sustaining a home environment where children experience Jesus, or managing a business with Christian principles. Christians are privileged to be outrageously generous in the business of living, dispensing the invaluable gifts of the Master and offering to others a taste of Christ's compassionate rule, like fine wine served at a wedding feast.

Identify one or more ways in which you can be part of the outrageously generous life of God's kingdom. How can you give God's invaluable gifts to others in the future? How can your congregation be more true to this picture of Christ's compassionate rule?

Such a privilege may be the envy of those who have come to work in the vineyard in the later years of life. Rather than feel they have the better deal, the latecomer to faith expresses regret for years wasted in pointless living. I have never heard a new convert taunt a Christian "lifer," saying, "Ha! Didn't you get the short end of the stick! You've been at this kingdom labor for thirty years, I'm just starting, and we both get the same gift of

eternal life!" On the contrary, new converts wish they had known years before of the riches of God, realizing they have missed out on years of good and gracious living.

Tony Campolo, an author and popular speaker, expounded on the invaluable joy of Christian service at a conference in Vancouver, British Columbia. At one point he cited Mother Teresa as an example. "Can you imagine Mother Teresa getting up each morning and mumbling to herself, 'Here we go again. Another lousy day in the streets of Calcutta. I'd rather be in Rome enjoying the luxury of St. Peter's cathedral'?" Of course not. Judging by her zeal, undiminished by her age, she went to the outcast and the leper to make a difference with the unlimited grace of God. She seemed to have grasped profoundly what Jesus meant when he said the first will be last and the last will be first. She served faithfully the most underprivileged people of the world.

Children, the poor, the outcast, the terminally ill, the nobodies in the world are first in the eyes of God. They "deserve" God's love as richly as anyone high on the world's social scales. At the same time, the worldly rich and "self-sufficient" need God's grace as badly as the last and least of our society. Spending energy and life serving the last in the eyes of the world is a sure sign that one has caught the spirit and message of the landowner.

Rembrandt's portrayal of the master dispensing outrageous generosity without discretion creates a community of hardy, industrious happiness and life-giving busyness. Who gets what for serving how long is really beside the point.

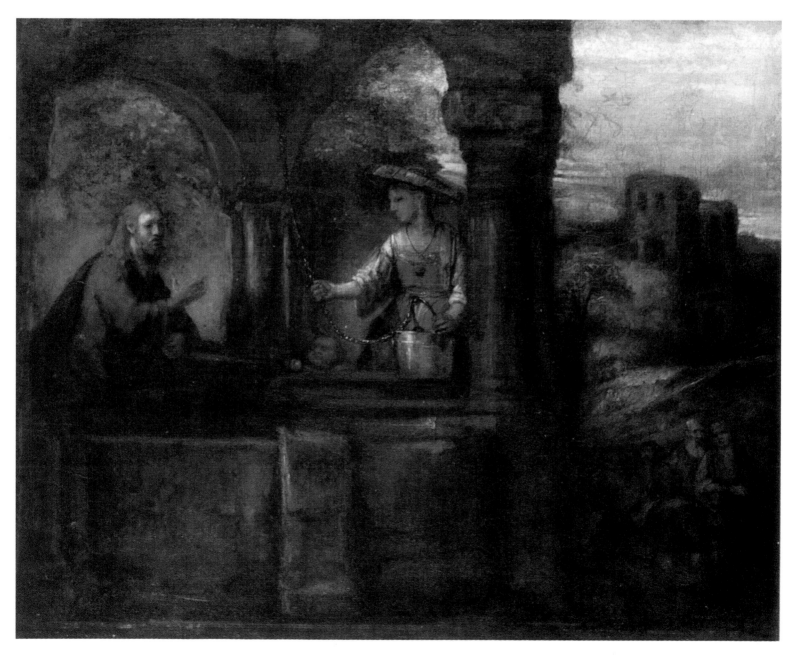

Christic and the Woman of Samaria ℒɐ The Hermitage, Leningrad ℒɐ circa 1659, 60cm x 75cm

CHAPTER 6

The Water of Inclusion

In 1513, the ambitious Spanish explorer Ponce de Leon came to America in search of the fountain of youth. Somewhere in the heart of this new land he believed there flowed a spring of fresh water that offered eternal youth—one good draught would be enough to guarantee it!

Ponce de Leon never found that fountain. He went back to Spain, and he died.

Almost five hundred years later we're still looking for that secret of eternal youth, albeit in different forms and places. Scientists have produced a synthetic form of the hormone called melatonin. Naturally produced in the pineal gland, a pea-sized organ embedded under the brain, this hormone is secreted as we sleep. It helps us sleep well, increases our desire to live, prevents hair loss, and bolsters youthful energy. Now that we can mass-produce this hormone, we could ingest more of it and theoretically put off the inevitable onslaught of age. However, not everyone is rushing out to buy it.

Jesus brings us closer to finding the real secret of eternal youth. On one occasion he explains that there is "living water" which, once consumed, will cause everyone who drinks it to "never thirst" again (John 4:10, 14). He doesn't say it will keep a person young forever, but it will quench his or her thirst forever, and will "become in him a spring of water welling up to eternal life." Jesus' conversation with a woman alongside a well of spring water leads us to reflect on the secret fountain of refreshing life.

Now he had to go through Samaria. So he came to a town in Samaria called Sychar, near the plot of ground Jacob had given to his son Joseph. Jacob's well was there, and Jesus, tired as he was from the journey, sat down by the well. It was about the sixth hour.

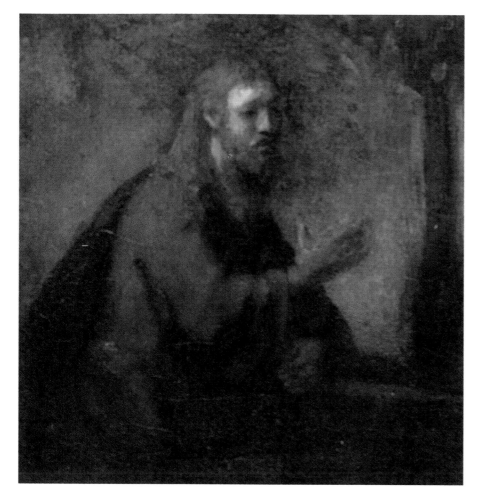

When a Samaritan woman came to draw water, Jesus said to her, "Will you give me a drink?" (His disciples had gone into the town to buy food.)

The Samaritan woman said to him, "You are a Jew and I am a Samaritan woman. How can you ask me for a drink?" (For Jews do not associate with Samaritans.)

Jesus answered her, "If you knew the gift of God and who it is that asks you for a drink, you would have asked him and he would have given you living water."

"Sir," the woman said, "you have nothing to draw with and the well is deep. Where can you get this living water? Are you greater than our father Jacob, who gave us this well and drank from it himself, as did also his sons and his flocks and herds?"

Jesus answered, "Everyone who drinks this water will be thirsty again, but whoever drinks the water I give him will never thirst. Indeed, the water I give him will become in him a spring of water welling up to eternal life."

The woman said to him, "Sir, give me this water so that I won't get thirsty and have to keep coming here to draw water."

He told her, "Go, call your husband and come back."

"I have no husband," she replied.

Jesus said to her, "You are right when you say you have no husband. The fact is, you have had five husbands, and the

man you now have is not your husband. What you have just said is quite true."

"Sir," the woman said, "I can see that you are a prophet. Our fathers worshiped on this mountain, but you Jews claim that the place where we must worship is in Jerusalem."

Jesus declared, "Believe me, woman, a time is coming when you will worship the Father neither on this mountain nor in Jerusalem. You Samaritans worship what you do not know; we worship what we do know, for salvation is from the Jews. Yet a time is coming and has now come when the true worshipers will worship the Father in spirit and truth, for they are the kind of worshipers the Father seeks. God is spirit, and his worshipers must worship in spirit and in truth."

The woman said, "I know that Messiah" (called Christ) "is coming. When he comes, he will explain everything to us."

Then Jesus declared, "I who speak to you am he."

Just then the disciples returned and were surprised to find him talking with a woman. But no one asked, "What do you want?" or "Why are you talking with her?"

Then, leaving her water jar, the woman went back to the town and said to the people, "Come, see a man who told me everything I ever did. Could this be the Christ?" They came out of the town and made their way toward him. . . .

Many of the Samaritans from that town believed in him because of the woman's testimony, "He told me everything I ever did." So when the Samaritans came to him, they urged him to stay with them, and he stayed two days. And because of his words many more became believers.

—John 4:4-30, 39-41

After reading the passage, study the painting. What details in the painting help you understand what was going on at the well? Where does the artist focus your attention? Why?

Thirsty People

The conversation Jesus initiates with the Samaritan woman at the well begins simply enough—with the pertinent topic of water to quench thirst. It quickly develops into a conversation of more profound matters. H_2O can slake a parched throat, but what can alleviate deeper spiritual and emotional needs?

The woman's circumstances eventually come to the surface. She has had five husbands and is now living with a man to whom she is not married. She has been looking for love in all sorts of places and faces. And the search is still going on. The ultimate questions—Where is true love? Who am I? Where do I belong?—seem to be going unanswered for her.

Such questions are still with us today. People are yearning to know where they belong. The irony of the modern society

ℒℬ

This painting has an unfinished look to it. Some parts, like the right hand of Jesus, seem incomplete and appear to need more detail. Some experts believe this is because the painting was inadequately preserved and thus has lost some of its clarity and detail. Others point to a retort Rembrandt once made when asked about a painting that seemed unfinished to an observer: "A painting is finished when the artist has achieved his aim in it."

—Gary Schwartz, *Rembrandt: His Life, His Paintings*, p. 364.

in which we live is that for all our increased technology in communication—cell phones, Internet, e-mail, fax machines—loneliness remains epidemic. We wonder where we belong. We search for community, a place to be loved and accepted for who we are, a place in which we can form our identity. Generation X-ers are viewed as the young who loathe the present and despair for the future. They feel that there is no place for them in society. "Where do we fit in?" they ask. Seniors feel pushed aside in our fast-paced world, their gifts and knowledge no longer needed, their experience and wisdom discarded for more advanced technological wizardry and the latest pop psychology. The unemployed search for work with fear in their eyes, wondering whether their skills are becoming obsolete. They question whether they are needed anymore. Foster children come of age and realize they really have no place to call home—no fixed address, no permanent family. And some people are working on a third marriage, praying that this will be the one to fill the void and bring happiness and fulfillment.

In painting this passage, Rembrandt represents the yearning of the Samaritan woman in a unique way. Although not mentioned in the biblical text, the woman is accompanied by a child. The child is, as it were, standing on tiptoes, chin up against the well, straining to peer over the edge and see what is down there. This curious child may represent the searching

soul of the woman and her spiritual quest for meaningful life.

In the children's story *The Velveteen Rabbit*, by Margery Williams, a stuffed toy rabbit is on a similar quest and wonders about being real. One day it asks the worn Skin Horse, a veteran of the toy population, "What is REAL?"

"Real isn't how you are made," says the Skin Horse. "It's a thing that happens to you. When a child loves you for a long, long time, not just to play with, but REALLY loves you, then you become Real. . . . Generally by the time you are Real, most of your hair has been loved off, and your eyes drop out and you get loose in the joints and very shabby. But these things don't matter at all, because once you are Real you can't be ugly except to people who don't understand."

The Samaritan woman is looking for life that is real. Her entourage of husbands indicates her hunch that real life is related to being loved. She just hasn't come upon the kind of love that creates the experience of really living. Her inquiry of Jesus about the proper place to worship is often interpreted as a ploy to change the topic—she doesn't like the way the conversation is heading toward her numerous liaisons with men, so she seeks to divert Jesus' attention to something a little less personal. But actually her question about worship does relate directly to the issue they are discussing—where to find true fulfilment and the source of meaning. She may be coming to the realization

that true satisfaction is found in God, and she is wondering where she can find him.

Jacob's Well

The well is a dominant feature in the artist's telling of this episode, filling about two-thirds of the total canvas. It appears to carry significance to Rembrandt in interpreting and grasping the spiritual truth of this New Testament passage. Although Jacob's well is not mentioned in the Old Testament, John mentions it specifically when he records this episode.

"Sir," the woman said, "you have nothing to draw with and the well is deep. Where can you get this living water? Are you greater than our father Jacob, who gave us the well and drank from it himself, as did also his sons and his flocks and herds?"

—John 4:11-12

This cistern seemed to hold an aura for the Samaritan woman. The great patriarch had dug the well, drank its refreshing water himself, and shared its rejuvenating freshness with offspring and herds. It serves as a visible symbol of Jacob's status, an indication of his prosperity and place in God's history with humanity. The well recalls the historically significant story of a young man running for his life from an angry brother, with nothing but a father's blessing. That young man would, years later, return weighed down with wealth— flocks, cattle, servants, wives, children, grandchildren, and finally his *own* land on which to dig a well. Established, prosperous, secure, and blessed. This well testified of God's goodness in bringing Jacob

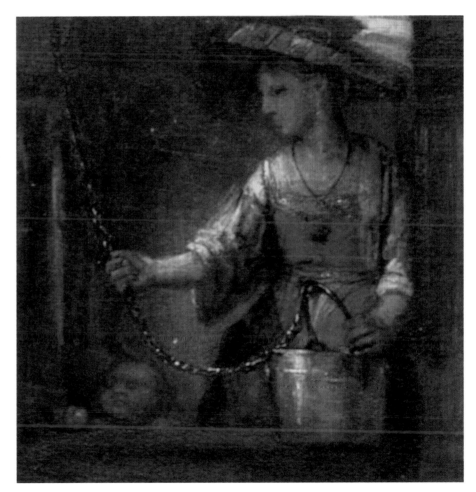

from rags to riches, from need to fulfill-
ment.

─────────────

What visible, tangible symbols of God's grace and goodness can you identify—symbols that have meaning for you as the well did for the Samaritan woman?

─────────────

The Samaritan asks this stranger a key question, "Are you greater than our father Jacob?"

She wonders if Jesus can give more than Jacob. Are you able to meet needs that this well-historied cistern, and all it repre-sents, cannot fulfill? As Rembrandt creat-ed this work in 1659, in the later part of his life, he likely asked the same question of himself. The fame and popularity he had experienced brought with it mone-tary gains, luxuries, and company with the high society of the day. Later in life, through the illness and death of loved ones, mismanaged funds, and turbulent relationships, he learned that material wealth and fame fall short of addressing our deepest needs. *Christ and the Woman of Samaria* communicates a Jesus who addresses those deep places.

Thirst Quencher

Cornelius Anslo was a gifted and notable Mennonite preacher who lived and served in Amsterdam in the seven-teenth century. He and Rembrandt be-came good friends. Over the years, the artist painted and etched a number of portraits of this preacher. However, a pop-ular poet of Rembrandt's day, Joost Van

※

Pastor Lee Strobel, in his book, *What Jesus Would Say*, imagined Jesus talking with pop-singer Madonna: "I think Jesus would tell her, 'I understand what happens when I'm missing from the core of a person's life. I understand how you feel compelled to search elsewhere for significance, affirmation, acceptance, self-worth, fulfillment, and love. That search has taken you to some dangerous and destructive places—and you still haven't found what you're looking for. You see, the frustration you feel is because the only thing that can really satisfy the center of your soul is Me.'"

—Lee Strobel, *What Jesus Would Say*, p. 24.

Den Vondel, challenged the artist to have his paintings actually *speak* with respect to Anslo. The poet writes,

> O, Rembrandt, paint Cornelius' voice.
> The visible is the least important part of him:
> The invisible one only learns through the ears.
> He who wants to see Anslo must hear him.
> —Jakob Rosenberg, Seymour Slive, E. H. ter Kuile, *Dutch Art and Architecture, Pelican History of Art,* p. 107.

In 1641 Rembrandt produced another portrait, *The Mennonite Preacher Cornelius Anslo and a Woman,* where the preacher is seated at a table, consoling a woman who appears troubled. A large Bible lies open on a table together with other books and a candle. The pastor's hand gestures towards the Bible as he looks at the woman earnestly. "The most intense light is given to the head and hands of the woman. Rembrandt shows the moment when she begins to forget her sorrow and feel the effect of the preacher's words" (Rosenberg, Slive, ter Kuile, p. 107). As viewers observe the painting, we sense the power of Anslo's speech. It seems the artist has met the poet Van Den Vondel's challenge.

Christ and the Woman of Samaria has a similar effect. The Jesus pictured sits with hand extended, offering water far superior to the water forty feet below him, superior to all the riches Jacob had to offer. The woman stands contemplating the invitation. Her face shows curiosity with eyes slightly downcast, realizing her desperate need for such water to give her the love she is looking for. Her stance—firmly holding bucket and rope—expresses a ready eagerness to quaff such water. John tells us that she heard the invitation of Christ and responded in hope (John 4:29). Jesus knew everything—her history with all its shortcomings, bad decisions, misguided love searches—and still he reached out to her. He brought her into a place of belonging, a relationship of genuine love, and the experience of true community.

The Skin Horse in *The Velveteen Rabbit* was right: we become real when we are truly loved. The woman sensed Jesus' genuine love for her—a love with no sexual strings attached. In conversation with him she felt real. He was right—this was even better than what Jacob had to offer!

Identify one or more concrete ways in which the church can offer Christ's genuine love to outsiders—love with no strings attached.

Our world offers all sorts of beverages, many promising to quench our most profound thirst. But Pepsi or Coke, milk, apple juice, Gatorade, or even V8, healthy as it is, fail to take care of our thirst for good. Popularity, beauty, romance, sex, and education may all be part of life and fulfillment, but they too fall short of providing full satisfaction in themselves. Our search for self-worth and acceptance can take us to strange and sometimes perilous

"In [Rembrandt's] view, the common people of Leiden or Amsterdam were essentially no different from the towering figures of the Bible, created by the same God, sharing the same mysterious destiny, feeling the same passion and despair." In fact, "it was exactly among the lower orders that Rembrandt perceived King David or Christ himself."

—Robert Wallace, *The World of Rembrandt,* pp. 40-41.

Pastor John DeVries challenges us to transcend human barriers and break through comfort zones to share the water of Jesus with the thirsting. He comments that many Christians live on "happy-land plateau," a plain where they have enriching fellowship with other believers, read inspirational books, listen to gospel music, and tune in to Christian radio. We live in a supportive community and feel we belong. We're happy most of the time. From time to time we get close to the edge of this plateau and we peek over—down there we see the dirt, the smelly swamp, the mud, and we draw back. But then, once in a while, we slip. We fall over the edge and get involved with one or two messed-up lives—people who may not know Christ and are dealing with complicated problems. We get caught up with hurting people, lonely people. We reach out to them as they reach out to us. And as we extend the compassion of Christ, we see change in their lives and in ours. We experience a joy not yet experienced, even on the plateau. The water that has included us in God's embrace has spilled out and quenched the thirst of another.

places. But the only one who can really satisfy us at our very core is Jesus.

Rembrandt himself had tasted the water Jesus offered. His work in art testified to this reality. Vincent VanGogh said of Rembrandt's work, "It is impossible to look at Rembrandt's art and not believe in God" (Paul Hanlyn, *The Life and Times of Rembrandt*, p. 40). When we take the time to gaze and reflect on the work of this Dutch master's depiction of Christ's encounter with the Samaritan woman, we not only see but also *hear* the message of Jesus. In Jesus, regardless of our past, our faults, our mistakes or missed opportunities, we find a place to belong, the complete fulfillment of our deepest needs.

The Water of Inclusion

Drinking the water of eternal life and being a fountain of such life entails a foundational reality we have not touched on yet. The disciples in the background of the painting approach the well with some questions on their minds. They are whispering to each other. John tells us that "they were surprised to find him talking to a woman. But no one asked [out loud, at least], 'Why are you talking with her?'" (John 4:27).

Animosity between Jews and Samaritans had a long history. In 722 B.C. a remnant of the ten northern tribes of Israel stayed behind while the rest were sent into exile by the Assyrians. Those who remained behind eventually intermarried with the Assyrians who began to occupy the land. These became the Samaritans.

Meanwhile, the Jews in the southern tribes remained ethnically pure, refraining from intermarriage with foreigners. These Jews considered the Samaritans unclean. Tensions heightened during the time of Ezra and Nehemiah, when the Jews refused to let the Samaritans help in rebuilding Jerusalem. Subsequently, the Samaritans established a rival temple and priesthood on Mount Gerizim. This effectively made the breach irreparable.

Antagonism was lively in Jesus' day. Jews would rather make the longer trip around Samaria than travel through it. Jesus, however, had no problem traveling through this country. In fact, John tells us that Jesus *had* to go through Samaria (John 4:4). It was necessary for him to do so. It would give him the opportunity to share life-giving water.

A fresh and careful reading of the gospels reveals a Jesus who regularly transgressed the established norms of cultural and religious structures, driving many religious leaders crazy. This wandering Teacher was always coloring outside the lines! In this particular incident with the Samaritan woman Jesus transgressed on three counts: one, the woman was a Samaritan; two, he was addressing a woman in public; and three, he was conversing with an immoral individual. For any one of these reasons, and in her case for all three, he was supposed to have shunned her. What does he do? He engages her in intimate conversation! All to offer her intimate and real life with God. Jesus had no patience for human barriers that hindered anyone—good, bad, moral, or immoral—from knowing true life in God. The water Jesus offers is inclusive, so inclusive that it breaks through the most stubbornly entrenched forms of exclusion.

Identify some barriers we've erected that may keep people from knowing true life in God. How can we begin to break down those barriers?

The painting uses the structure of Jacob's well to communicate Jesus' identification with the woman and define their relationship. In symbolic terms, historical Christianity viewed the well as a symbol of purification and virginity. Rembrandt has understood the woman's personal meeting with Christ as an experience that cleansed her from her past and gave her a new beginning.

Water to Spare

Christ had a way of being in touch with many who were regularly barred from privileges of society—lepers, tax collectors, prostitutes, those who were crippled, blind, deaf, or poor. These people, who were scorned and avoided by the rest of society, were loved by the One who could see that they were God's children, created in God's image. Gladly, he shared thirst-quenching water with them, including them in fellowship with their Maker.

Rembrandt seems to have taken this attitude of Christ's to heart. He spent time in the company of those in the lower

class; Jewish people, who were shunned for much of the seventeenth century; and others who were on the fringe of society. One Rembrandt biographer, Sandrart, "criticized [Rembrandt] for spending too much time among 'the lower orders' of society, and maintained by implication that Rembrandt might have been a better artist if he had learned to 'keep his station'" (Robert Wallace, *The World of Rembrandt*, p. 41). As the artist sought to emulate the spirit of Jesus, accepting the less privileged and welcoming them into his community, he increasingly saw the connection common folk had with the characters of the Bible. This in turn inspired the unique and penetrating vision so evident in his art.

Jesus said, "Whoever drinks the water I give him will never thirst. Indeed, the water I give him will become in him a spring of water welling up to eternal life" (John 4:14). Having been included unconditionally into the family of God, Christ-followers are called to be inclusive in turn. Let the life-changing water we've ingested bubble forth in refreshing streams for those who are thirsty, no matter who they are. Whether these people are acceptable or unacceptable according to the norms of our society, Christians are called to view them with the eyes of Jesus. Through Jesus' eyes we see beauty in people and places our world would never suspect. And we have abundant, eternal life to respond to their need—water to spare, life to share!

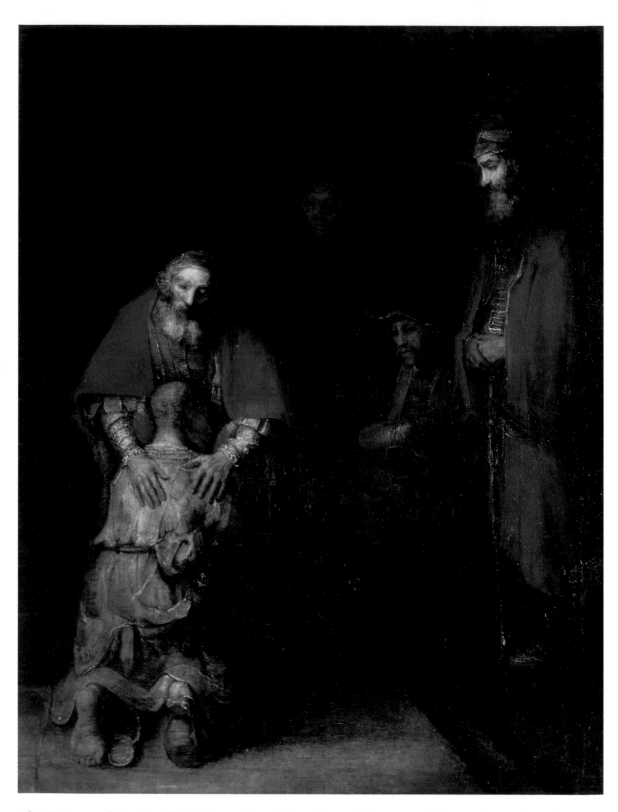

The Return of the Prodigal Son ❧ Hermitage Museum, St Petersburg, Russia.
Bridgeman Art Library, London/SuperStock ❧ circa 1669, 206cm x 205cm

CHAPTER 7

Embrace of Forgiveness

*T*he *Knot of Vipers* by François Mauriac tells the story of a husband and wife who are tangled up in a world of unforgiveness. Their relationships with their children caused a deep rift to develop between them. According to her, he had not shown enough concern for their five-year-old daughter when she became ill thirty years ago. According to him, she lived only for her children, paid no attention to him once they were born, and found her purpose in life as a mother, not a wife. And so for years they slept in separate rooms. Neither was willing to take the first step to reconciliation. Each night she would lie awake and wait for him to come. Likewise, he would wait for her to appear in the doorway and offer words of forgiveness. But neither would break the cycle that had begun years before. Unforgiven, they were "two individuals living a life of constant exasperation and mutual loathing" (p. 278).

Our wounds are most often caused by someone close to us. Like a blunt knife, they tear into our tender psyches. We learn to live with these wounds, getting used to the idea that some unresolved matters are off limits for discussion. We avoid them for the sake of pseudo peace. Life demands that we get around these difficult areas somehow so that we can function as a family, but issues never resolved translate to hurts never healed. A scab may develop for protection, but the infected incision never fully heals—and sometimes quietly bleeds.

Is there any way to resolve these matters, heal the hurt, and stop the bleeding? Toward the conclusion of her study on the human condition, Hannah Arendt, Jewish philosopher, "shared her discovery of the only power that can stop the inexorable stream of painful memories: the 'faculty of forgiveness.' It is as simple as that. Forgiveness is God's invention for coming to terms with a world in which, despite their best intentions,

people are unfair to each other and hurt each other deeply" (Lewis Smedes, *Forgive and Forget*, p. 12). Forgiveness is an experience like no other. It is no wonder that the parable that illustrates with reckless clarity the power of forgiveness stands as one of Jesus' most familiar. As we listen to Luke tell the story, we have opportunity to reflect on the place of forgiveness in our own experience.

Jesus continued: "There was a man who had two sons. The younger one said to his father, 'Father, give me my share of the estate.' So he divided his property between them.

"Not long after that, the younger son got together all he had, set off for a distant country and there squandered his wealth in wild living. After he had spent everything, there was a severe famine in that whole country, and he began to be in need. So he went and hired himself out to a citizen of that country, who sent him to his fields to feed pigs. He longed to fill his stomach with the pods that the pigs were eating, but no one gave him anything.

"When he came to his senses, he said, 'How many of my father's hired men have food to spare, and here I am starving to death! I will set out and go back to my father and say to him: Father, I have sinned against heaven and against you. I am no longer worthy to be called your son; make me like one of your hired men.' So he got up and went to his father.

"But while he was still a long way off, his father saw him and was filled with compassion for him; he ran to his son, threw his arms around him and kissed him.

"The son said to him, 'Father, I have sinned against heaven and against you. I am no longer worthy to be called your son.'

"But the father said to his servants, 'Quick! Bring the best robe and put it on him. Put a ring on his finger and sandals on his feet. Bring the fattened calf and kill it. Let's have a feast and celebrate. For this son of mine was dead and is alive again; he was lost and is found.' So they began to celebrate.

"Meanwhile, the older son was in the field. When he came near the house, he heard music and dancing. So he called one of the servants and asked him what was going on. 'Your brother has come,' he replied, 'and your father has killed the fattened calf because he has come back safe and sound.'

"The older brother became angry and refused to go in. So his father went out and pleaded with him. But he answered his father, 'Look! All these years I've been slaving for you and never disobeyed your orders. Yet you never gave me even a young goat so I could celebrate with my friends. But when this son of yours who has squandered your property with prostitutes comes home, you kill the fattened calf for him!'

"'My son,' the father said, 'you are always with me, and everything I have is yours. But we had to celebrate and be glad, because this brother of yours was dead and is alive again; he was lost and is found.'"

—Luke 15:11-32

Spend some time with the painting after you have read the parable. What does Rembrandt's portrait of the father tell you about the painter's relationship with God?

Rembrandt's depiction of this parable, created in the last year of his life, is recognized as one of the most spiritually penetrating masterpieces ever painted. Henri Nouwen, in a book dedicated to an exploration of this work, writes, "I found great consolation in reading the tormented life of the great Dutch painter and learning more about the agonizing journey that ultimately had enabled him to paint this magnificent work . . . and I came to understand how from his brush there emerged the figure of a nearly blind old man holding his son in a gesture of all-forgiving compassion. One must have died many deaths and cried many tears to have painted a portrait of God in such humility" (*The Return of the Prodigal Son*, p. 21).

The popular name for this parable is "The Prodigal Son." But although the two sons have their own heartfelt stories to tell, the story rests with the father. In the end, he takes the day—his actions speak most loudly to us. Rembrandt's painting of this parable powerfully reveals the artist's astute contemplation of the point Jesus was making in the narrative.

꽃

Henri Nouwen relates the condition of the son to the modern scourge of addictions. "'Addiction' might be the best word to explain the lostness that so deeply permeates contemporary society. Our addictions make us cling to what the world proclaims as the keys to self-fulfillment: accumulation of wealth and power; attainment of status and admiration; lavish consumption of food and drink; and sexual gratification without distinguishing between lust and love. These addictions create expectations that cannot but fail to satisfy our deepest needs. As long as we live within the world's delusions, our addictions condemn us to futile quests in 'the distant country.'"

—Henri Nouwen, *The Return of the Prodigal Son,* p. 21.

Tied Up in a Glamorous World

The younger son cannot resist the enticing pull of a distant country's greener grass. He has caught a glimpse of the land of unlimited liberty, a place with no restrictive rules to cramp his style or curb his desires. He's eager to be out from under the watchful eye of his father.

And he's tired of sibling rivalry—how free it would feel to be beyond his older brother's reach! Anyone who has been a teenager can relate. Remember the freedom of that first drive in your parents' car with your newly acquired driver's license, alone or with some impressionable friends? Remember heading off to college or university? The taste, the sights, the spine-tingling feel of big-city excitement, night life with no curfew. Indulging every whim, over and over and over again— what bliss! Expensive thrills, extreme chills—snowboarding, bungee jumping, parasailing, whitewater rafting, stock-market maneuvering, bank-account building, casual sexuality—a huge swan dive into the pleasure pond. There he "squandered his wealth in wild living."

Quickly this son's pleasure becomes his plight. When the money runs out, the friends disappear. The land of promise fails to come through on its pledge of perpetual fun and freedom. The young man finds himself slopping around in the mud with pigs. For a Jewish lad, feeding the pigs of a Gentile farmer in a foreign land is about as far from home and well-being as one can get. The land of liberty turns into a land of slavery. His wayward-

ness has led him into bondage. His unchecked yearning for the free life has landed him in the grip of prison. Rembrandt has depicted his state by painting the son with a head shorn of hair. In contrast to the other characters in the painting who have distinctive locks of hair or headdress, the younger son is bald. Like an inmate whose name is replaced with a number, who bears no mark of individuality, he resembles a captive in a concentration camp.

If Rembrandt were painting today, what details might he have included to help us understand the condition of the younger son?

Common Sense

Without a cent to his name, the young man came to his senses. He came to that place where he knew there had to be more to life. You know that restless feeling: Is this really what life is all about? What am I doing here? He came to his senses and said, "I will go back to my father. . . ."

In these words Rembrandt has perceived the key to the son's change in plight. The kneeling son in the painting possesses one item at odds with his condition. In the midst of the worn garment, the hairless head, the tattered sandals, he has a sword strapped to his waist. The sword is a sign of nobility, a badge of honor indicating one's status. The son has

nothing left but this one truth—he is still a son, who still has a father.

Not too long before, when things were going merrily, this truth never crossed his mind: out of sight, out of mind and heart. In fact, his earlier treatment of his father was nothing less than contemptible. His request to have his share of the inheritance, done with such conviction and heartless calculation, morally expressed his wish for his father's death. He had shamed his father before his neighbors. Oblivious to the disappointment he had caused to the one person who loved him more than anyone else in the world (except perhaps his mother), he set off. At this point the father ceased to exist in the heart of the son. But in spite of all this, the fact remains unchanged: he still has his father, and he is still a child. No matter what happens, we remain a daughter, a son of the Father.

With this one slim but unbreakable thread of truth giving him hope, the son gives notice to his boss and heads home. "I will go to my father. . . ."

When was the assurance that no matter what happens we remain sons and daughters of the Father especially comforting to you?

Hands

It turns out that the father had not lost hope that the son would return one day. His eyes periodically surveyed the horizon, waiting to catch the still-familiar gait

President Abraham Lincoln was advised by his political colleagues to punish the southern states severely for the turmoil they had caused during the American Civil War. His unforgettable words of response revealed a powerfully different approach in overcoming the opposition. "Do I not destroy my enemies when I make them my friends?" (Philip Yancey, *What's So Amazing About Grace?*, p. 98). Based on such a forgiving spirit, the president led the country from the fractious fallout of war to healing that eventually spawned a united nation.

of his wandering son. Luke describes the father's reaction when he finally sees the figure: full of energy and action, he runs, shouts commands to his servants, falls on his son, and profusely kisses him. Rembrandt's image is more subdued, but no less evocative. The father appears slightly blind, a common theme of the artist, who believed that the elderly who are physically blind possess sharp spiritual vision. In this instance, the overwhelming spiritual dynamic is divine forgiveness. Flowing down over the shoulder we see the red cape, blood red being the color of forgiveness. The royal canopy flows over the father's shoulders and envelops the son pressed against his chest. The painting illustrates the two as one inseparable unit.

The hands of the father image are pivotal. They speak of the artist's biblical insight into the heart of God. Hands, so prominent in Rembrandt's work, served as instruments to express emotion and spiritual reality. In *The Return of the Prodigal Son* they reveal the inner eye of a personal God who could not be described exclusively in masculine terms. The left hand appears as the hand of a man—firm, large, and wide—pressing the shoulder of the son. But the right one has a distinct feminine quality—gentle, tender, caressing. Such insight on the artist's behalf reflects biblical imagery of God—a being who is described in both masculine and feminine terminology. As deep as the embracing love of a mother or a father is for their child, it pales in comparison to God's resolute embrace. Although we may

feel at times that the Lord has forsaken or forgotten us, Isaiah reminds us, "Can a woman forget the baby at her breast and have no compassion on the child she has borne? Though she may forget, I will not forget you! See, I have engraved you on the palms of my hands" (Isa. 49:15-16).

In the human hands of Jesus we witness the painful price the Father had to pay at the cross to extend forgiveness to us. Forgiveness is not free. It cost God dearly. The hands of God are literally marked by the scars in the hands of Jesus. The Son's mutilated hands declare that the Father will stop at nothing, not even death or hell, to reach out to us and take us in. God embraces us and so saves us from our own predisposition towards wayward amusements.

Although masculine imagery for God is most common in the Bible, some female imagery is used as well. For examples, look up the following passages: Job 38:29; Psalm 123:2; Isaiah 42:14; Isaiah 49:15. What do these images tell us about God?

Embrace of Forgiveness

The son returns to find true liberty, the freedom he set out searching for in the first place. There it was, right at home! He just hadn't seen it. The father's embrace, declaring unconditional forgiveness and full acceptance, brings the younger son peace and full satisfaction. Once in a while we may be struck by our own wayward shortcomings. Honestly facing our

Rembrandt was no stranger to the stifling hardness unforgiveness can create. One difficult chapter of his life involved a woman, Geertje Dircx, who lived with him to care for his son after Saskia died. Although the depth of intimacy of their relationship is somewhat ambiguous, we do know that after six years the relationship went sour and circumstances went awry. Barbara Rose notes, "Rembrandt maintained alliance with [Dircx] until 1649, when, after many quarrels, she brought lawsuit against him. The records of this affair reveal Geertje as a hysterical and stubborn woman" (*The Golden Age of Dutch Painting*, p. 170). But of course there is always more than one side to a story. Rembrandt used Dircx's brother, who had been given power over her by Geertje herself, to collect evidence against her to have her put into a mental institution. When the possibility arose that she would be released, Rembrandt arranged for more evidence to be brought forward to keep her detained. The culmination of all this turmoil in 1649 affected the artist. That year was the only year in Rembrandt's adult life in which he did not produce any work of art. The artist's creative genius was paralyzed due to a consuming vengeance and bitterness.

—Gary Schwartz, *The Complete Etchings of Rembrandt*, p. 11.

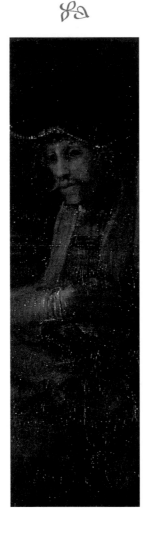

human weaknesses, we wonder and may become afraid that even our spouse may lose his or her love for us. After all, we muse, my body isn't that attractive, at least not according to Hollywood's standards. And I'm really not such a hot parent or super spouse, in spite of the Father's Day cards that speak to the contrary. Then your loved one does something that tells you that you are loved and accepted just the way you are! (Sure, they would like some things to change, but this love, this acceptance, is not in jeopardy.) Your head begins to swim, your heart begins to swell, you get all shook up inside, and your eyes get misty. Then you know you have experienced freedom. You are free to be yourself, as you honestly are, with this person. Free to be who God created you to be, to celebrate the life God has given, the family God has given. Free to forgive in turn. To be a forgiving person.

Such new life, initiated by forgiveness received and given, was not lost on Rembrandt. Earlier we noticed the shaved head of the son as a sign of nonidentity and lostness. But in the embrace of the father, that head can also be seen as the head of a newborn child—just come forth from the womb, entering life. Forgiveness means a new life, a new beginning. "This son of mine was dead and is alive again; he was lost and is found."

Forgiveness brings resurrection to people and to whole communities.

Over the past years our world has watched while the Cold War ended in a way that few world leaders would have predicted. Communist regimes crumbled without a shot being fired. We heard stories and saw film footage of literally thousands of peaceful demonstrators holding candlelight vigils in town squares and churches and singing hymns as they paraded down streets while police and soldiers stood by and seemed powerless against such a force. Former United States senator Sam Nunn said that the Cold War ended "not in a nuclear inferno, but in a blaze of candles in the churches of Eastern Europe" (Philip Yancey, *What's So Amazing About Grace?*, p. 135). The transforming power of forgiveness rooted in love brings rebirth to individuals and to nations.

When have you encountered this transforming power of forgiveness in your own life? In your family? In your church? Elsewhere?

The Older Brother

Standing to the right of the father and younger son is another character. Although, according to the biblical account, the elder son did not witness the return of his younger brother, he was inextricably involved, as the parable bears out. *The Return of the Prodigal Son* seeks to visually portray the attitude of the elder son and his relationship to his father. Usually, the son who is understood to be lost when we reflect on this parable is the younger son. But what about the older son? Is he lost too?

Luke tells us that the elder brother was furious. Both his posture and face express

his anger—not with a spurious burst of temper, but in a disturbingly quiet way. His body remains erect, unbending. Hands, in such striking contrast with the father's, are folded and held against his body. He holds a staff, symbolic of judgment and disapproval. His face, the set jaw and cold eyes, exude disdain towards this sniveling little brother who has come crawling home like some hopeless beggar. Toward his sibling we sense his jealous hatred, toward his father bitter resentment.

It takes little effort on our part to understand the feelings of the older brother; in fact, it may come easily to us. Who of us have not been hurt on account of some spoiled sibling and indulged the satisfaction of nursing a grudge? The older brother took the words right out of our mouths, "All these years I've been slaving for you. . . . I've been faithful, loyal, law-abiding—always there for you, respecting you, going by the rules, being the ever-helpful and available servant . . . and now this ungrateful renegade comes begging back after a reckless, selfish, wasteful binge, and look at the welcome he gets! Hard to comprehend! Makes no sense to me."

How easy for us to entertain such justifiable lines of argument. Such an argument hardens into something permanent, like a barrier that solidifies between sister and brother, husband and wife. Anger, malice, bitterness, and resentment are bricks in the wall, making forgiveness an ever more remote possibility. Like the couple in François Mauriac's novel, we

hole up in the fortress of pride, hurt by some injustice done against us long ago. While hungering for forgiveness, for love, for joy, for freedom, we are unable to do what it takes to break down the barrier.

So although it's the younger, runaway son who normally is labelled "lost," further reflection makes us wonder whether the elder son was lost as well. He stayed home and dutifully worked for his father, but his relationship to the father seems to lack closeness. Instead, the story and Rembrandt's painting convey a cool, reserved distance between father and son. Henri Nouwen observed, as he reflected on the painting in St. Petersburg,

> Here I see how lost the elder son is. He has become a foreigner in his own house. True communion is gone. Every relationship is pervaded with darkness . . . sins cannot be confessed, forgiveness cannot be received, the mutuality of love cannot exist . . . everything loses it spontaneity. Everything becomes suspect, self-conscious, calculated, and full of second-guessing. There is no longer any trust. Each little move calls for a countermove; each little remark begs for analysis; the smallest gesture has to be evaluated. This is the pathology of the darkness.
> —Henri Nouwen, *The Return of the Prodigal Son*, p. 82.

Rembrandt has portrayed the elder son surrounded by darkness—detached in space, in stance, and in facial expression

from the reunion of his father and younger brother. When the lubricating oil of forgiveness has dissipated, the gears of human relationships grind to a deadly halt.

How are members of the church sometimes in danger of becoming "lost at home"?

Forgiveness Again

Jesus continues with the story, telling us that the father performs another highly unusual act—he leaves the celebration going on in the house and goes out to entreat his elder son. In biblical culture this was unheard of. A host did not leave the party, especially to go out and try to persuade a reluctant inferior to come and join in on the festivities. But this is a father who longs for the life and joy of all his children. So he, as it were, humbles himself and seeks the older, wandering son.

The elder son has no problem expressing his anger with articulate words. His logic is airtight: "I have been faithful, a son to be proud of, yet have asked for little. He has been an embarrassment, and he gets the homecoming party." The father's response does not try to counteract the argument of the son. Logic will not prevail here. Only the loving embrace of forgiveness—for the younger son *and* for the older son. "We've always had each other; we're together and all I have is yours. But this brother of yours was lost. Yes, that was stupid and foolish of him.

You're right—he is an embarrassment. But he is part of the family, and he was dead and is now alive. It's only right that we rejoice, give thanks, and celebrate life."

This response of unconditional forgiveness does not refute the logic of the elder son. Nor does the father's answer tidy up all the moral and spiritual loose ends. Author Lewis Smedes, on reflection of a personal experience, wrote, "[Forgiveness means] we gave up trying to keep score of who did what to whom and how badly it hurt. We learned to leave the loose ends dangling, the scales off balance, to accept a score that neither of us could make come out even" (*Forgive and Forget*, p. 140). We will never come to a place of peace if it means getting everything evened out between myself and my spouse, or my fellow church member, or sister or brother, parent, son, daughter. Forgiveness offers us a way out, a chance to begin again. This the father knew. And this is what God knows.

The act of forgiveness may seem to be, and can in fact be, unfair and untidy, but in the end it is the only way to live. The alternative leads to a miserable existence of fragmented relationships and fractured communities. The most convincing argument for living with a forgiving spirit is the alternative, that is, living without it. As unfair as it may seem and feel, only forgiveness can halt the endless cycle of hurt and retribution.

Think about your personal experiences with forgiveness—both forgiving and being forgiven. How do they support the statement that forgiveness is "unfair and untidy"? What impact has forgivness had on your relationships with others?

The Return of the Prodigal Son works pointedly with the effect of *chiaroscuro*. The literal use of light and dark draws the viewer into the spiritual dynamics of shadow and light, forgiveness and unforgiveness. Rembrandt has created a work of synthesis between the physically visible and the spiritually invisible—divine and human intersect in the profound moment of this painting. "In the story one can imagine the elder son standing outside in the dark, not wanting to enter the lighted house filled with happy noises. But Rembrandt paints neither the house nor the fields. He portrays it all with darkness and light. The father's embrace, full of light, is God's house. All the music and dancing are there. The elder son stands outside the circle of this love, refusing to enter. The light on his face makes it clear that he, too, is called to the light, but he cannot be forced" (Nouwen, *Return of the Prodigal Son*, p. 74).

Jesus' telling of the parable and Rembrandt's painting do not indicate how the older son responded to the father's entreaty. This question is left unanswered, leaving us in suspense. As we reflect on the story through the words of Jesus and the artist's rendition, we begin to wonder about ourselves. How have I responded to the inviting embrace of the Father? Will I stand slightly to the side and ponder, asking if I really need such forgiving affection? Will I hesitate to accept, fearful of the life of forgiveness it would call me to live? Have I responded with joyful repentance, knowing I need this embrace to live? Have I discovered the inevitable truth that I need to come home?

The last word in this story belongs to the father, so prominent in the painting and so potent in the parable. The story is not ultimately about two sons—two brothers, one wayward and wicked, another self-consciously righteous. It is about the father, the only good. He loves both sons. He runs out to meet both of them. He invites both to celebrate at his table, in his home. He seeks you and me to accept his embrace and experience the joy of forgiven living. His eyes scan the horizon of the spiritual landscape, his feet are ready to run, his arms eager to embrace, his voice ready to proclaim, "Hurry! Fetch the best clothes . . . get the family ring . . . get the fattened calf and kill it, and we will have a feast and a celebration. For this is my child, who was dead and is now alive, was lost and is now found!"

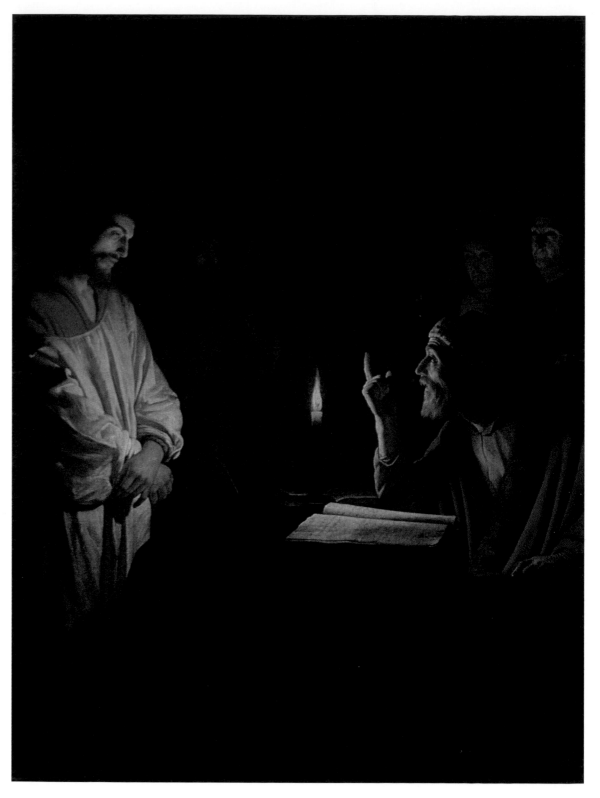

Christ Before the High Priest ᕘ Artist: Gerard Van Honthorst ᕘ National Gallery, London/SuperStock ᕘ circa 1617, 272cm x 183cm

Legalism's Quandary

In *The Great Divorce*, C. S. Lewis's amusing fantasy of departed spirits traveling between heaven and hell, a teacher explains,

> There have been men before now who got so interested in proving the existence of God that they came to care nothing for God Himself . . . as if the good Lord had nothing to do but *exist!* There have been some who were so occupied in spreading Christianity that they never gave a thought to Christ. Man! Ye see it in smaller matters. Did ye never know a lover of books that with all his first and signed copies had lost the power to read them? Or an organiser of charities that had lost all love for the poor? It is the subtlest of snares (pp. 65-66).

Lewis confronts us with the challenge to keep the main thing the main thing. The Bible does the same, reminding us to constantly check our tendency to get sidetracked from what really matters in life. How often are we in danger of missing the point of our faith? During his trial, Jesus addresses this matter with the high priest Caiaphas.

Those who had arrested Jesus took him to Caiaphas, the high priest, where the teachers of the law and the elders had assembled. But Peter followed him at a distance, right up to the courtyard of the high priest. He entered and sat down with the guards to see the outcome.

The chief priests and the whole Sanhedrin were looking for false evidence against Jesus so that they could put him to death. But they did not find any, though many false witnesses came forward.

꿈

This is the one painting in the book done by an artist other than Rembrandt. Gerard van Honthorst (1590-1656), well known over much of Europe, was a Dutch artist instrumental in bringing the art techniques of the Italian Renaissance to Holland. He was particularly gifted at painting night scenes, often using the effect of candlelight to create dramatic effects. He acquired the nickname *"Gherando delle Notti"* (Gerard of the night). After a time of study in Rome, he brought the use of light and shadow, *chiaroscuro*, from the Caravaggio school in Italy to Utrecht. Rembrandt learned much of this technique and was exposed to Caravaggio's work and style through van Honthorst. *Christ Before the High Priest* was commissioned by the Roman Catholic Church while van Honthorst was in Rome (c. 1617). It is probably his most popular painting, both in his time and today.

Finally two came forward and declared, "This fellow said, 'I am able to destroy the temple of God and rebuild it in three days.'"

Then the high priest stood up and said to Jesus, "Are you not going to answer? What is this testimony that these men are bringing against you?" But Jesus remained silent.

The high priest said to him, "I charge you under oath by the living God: Tell us if you are the Christ, the Son of God."

"Yes, it is as you say," Jesus replied, "But I say to all of you: In the future you will see the Son of Man sitting at the right hand of the Mighty One and coming on the clouds of heaven."

Then the high priest tore his clothes and said, "He has spoken blasphemy! Why do we need any more witnesses? Look, now you have heard the blasphemy. What do you think?"

"He is worthy of death," they answered.

Then they spit in his face and struck him with their fists. Others slapped him and said, "Prophesy to us, Christ. Who hit you?"

—Matthew 26:57-68

How do we tend to get sidetracked from "the main thing" as Christians? As congregations? As denominations?

Face-off

This encounter between Jesus and Caiaphas occurred during the week lead-

ing up to the crucifixion. Gerard van Honthorst's painting depicts the face-to-face dynamics at work in the encounter. The scale of the actual work is life size (272 by 183 cm) and has a powerful effect on the observer. The candle sheds light on the two main characters in this scene. It reveals the details of their faces and accents the heightening drama. Looking each other in the eye, the two men represent entities larger than themselves. Jesus represents the supreme revelation of God. Caiaphas represents the religious mindset of the Jewish people of his day.

The contrast is acutely marked. Caiaphas is dressed in a rich, regal gown. Jesus is wearing a plain, torn robe. Caiaphas is seated, supported by witnesses and an army. Jesus must stand alone. Caiaphas's hands are free, one to rest on the arm of the chair, the other to point. Jesus' hands are bound with rope. Undergirding Caiaphas's authority is the book of the law. Jesus is his own authority.

At stake in this trial is Jesus' identity. "Are you the Christ?" Are you the one sent by God, prophesied, expected, the one who would come to save his people? The one to bring the reign of God to earth? The Jews had many preconceived ideas of what the Messiah would look like and how he would act. The religious leaders of the day did not believe the Messiah would be God himself, since there is only one God. So to them it was blasphemy for Jesus to say he was God. Furthermore, they were convinced that the Messiah

would act within *their* concept of the law—for the law revealed Jehovah perfectly. This wandering preacher simply does not fit the bill. He doesn't warm up to the time-honored practices of the religious institutions of the day. He hangs out and associates with the unclean elements in society. Most disturbing and indicting of all, he claims to be not only the Messiah, but God himself! Blasphemy! The problem is, common folk are starting to believe him. He's backing up his words with action, showing authority, and his teaching holds them spellbound. What would happen if the masses fell for him? Something has to be done before things get out of hand!

In what ways might Jesus offend our religious and social sensibilities if he were to appear among us today? Where might he spend his time? What might he be critical of in your life? In your church/denomination?

So they plot to corner him. Matthew tells us outright that the religious leaders were looking for false witnesses against him. The Sanhedrin broke several of their own rules of proper order in their frenzied attempt to get rid of this "imposter":

- Two independent witnesses were required to testify—yet these two had schemed with each other and bore false witness. (Jesus had not said, "I will destroy this temple in three days and rebuild it." He had

said it would be destroyed and he would rebuild it.)
- The rules said trials were to be conducted during the day—yet these were all conducted in the dark hours of night.
- A final verdict was to be pronounced at least twenty-four hours after the last witness had testified to give the court some time to reflect properly. This session pronounced judgment immediately.

The Sanhedrin's ultimate goal was the permanent removal of this rabbi. How they reached this goal was really beside the point. Breaking a few rules of order along the way was no big crime.

As it turned out, Jesus obliged them by condemning himself with his own words—no false witnessing was needed after all. "Are you the son of God, the Christ?" "Yes, it is as you say. But I say to all of you: In the future you will see the Son of Man sitting at the right hand of the Mighty One and coming on the clouds of heaven."

The Grand Inquisitor

In Dostoyevsky's *The Brothers Karamazov,* a character named Ivan wrote a story about Jesus coming back to earth and visiting the town of Seville in Spain during the sixteenth century. The story was set during the "grimmest days of the (Spanish) Inquisition, when throughout the country fires burned endlessly to the greater glory of God . . . heretics burned

at the stake was a daily spectacle." Into this historical setting Jesus appeared, walking among the common folk in the town square. Light and understanding flowed from his eyes as he reached out to people, blessing and healing them with his touch. Meanwhile, a frowning cardinal, the Grand Inquisitor himself, watched all this from a distance. When Jesus was stopped by a funeral procession for a seven-year-old girl and raised the child back to life at the request of the mother, the cardinal could take no more. With darkened face, knit brow, and eyes that flashed with ominous fire he ordered his guards to seize Jesus.

In a narrow, damp prison cell the cardinal proceeded with his interrogation. Several times during the questioning he asked Jesus, "Why have you come to interfere with our work?" Apparently the message and ministry of Jesus, the Head of the church, was no longer consistent with the way the church thought and operated fifteen hundred years after his departure. In fact, the presence of Jesus had become an offensive and threatening interruption. The cardinal was visibly bothered by the presence of the church's Lord back on earth. Throughout the entire session Jesus had not uttered one word in his defense. The cardinal, realizing he was making no progress, declared, "Tomorrow you will see obedient herds, at the first sign of me, hurry to heap coals on the fire beneath the stake at which I will have you burned, because by coming here, you have made our task more difficult. If anyone has de-

served our fire, it is you, and I shall have you burned tomorrow."

Legalism's Quandary

Jesus proves to be the one who casts the legalistic mindset into a quandary. He creates a dilemma. The very rules and regulations that seek so hard to maintain righteousness and present us worthy before God are the things that blind us from seeing the nature of God—his wholly gracious and wholly loving nature. The rules of religion designed to lead us into a relationship with God, into life, in fact lead to death. Legalism shoots itself in the foot, or perhaps more accurately, in the heart. It is a dead-end road. It is Jesus who brings this to our attention. His life makes this point. In essence, Jesus is legalism's quandary.

How is a love for legalism sometimes evident in your church? In your personal life? How can we free ourselves from legalism?

Our only hope of salvation, of being in the kingdom, rests exclusively on God's grace. This was the message Jesus presented in word and life. If this Jesus of Nazareth were, in fact, the Messiah, if he did embody the invisible God accurately, then the religious leaders' concept of God was sorely off-base. They were missing the whole point! As C. S. Lewis writes, like people who love books so much they lose the power to read them, or people who get so caught up with charities they lose

Philip Yancey remembers "scores of sermons from my Atlanta church attacking civil rights and the Beatles. But I can't remember one against the bombing of a black church in Alabama. . . . We were too busy measuring [mini-] skirts to worry about war or racism or world hunger."

—Philip Yancey, *A Perfect Empty Shell Exploring Faith and Discipleship*, p. 66.

﷽

For many Christians, the Christian faith seems to be more of a burden than a blessing. For many Christians God's presence seems to be about as welcome as that of a police cruiser when they're speeding on the freeway. The Bible is treated as a heavenly version of the Highways and Traffic Act. And the church is seen as a kind of traffic court where guilty offenders gather to be sentenced and pay their fines. And worship is a plea-bargaining process where we hope a good showing will lighten our punishment.

—Bert Slofstra, "Have You Heard the Pop of the Cork Lately?"

their love for the poor, people who get so excited and preoccupied with all the rules can lose sight of the very God such rules reveal. If Jesus is right, then we've lost sight of what the God of the Scriptures is really like.

Christ Before the High Priest quietly reveals that such questions were on the mind of Caiaphas. In spite of his regal garb, the support he has around him, and the book placed at his disposal, the character hints at uncertainty. The high priest has an anxious look in his eye, a face that conveys tension. Although seated, he does not look relaxed. One hand grips the arm of his chair, the other hand holds up a finger in an attempt to maintain a disappearing façade of authority. In contrast, Jesus appears relaxed. Although his hands are bound, they are completely at ease. He carries an aura of peace. The candlelight reflects a face of calmness.

Christ's face also carries a hint of exasperation. He is tired of this game, this charade. Not only the charade of the trial, but the whole legalistic approach to his Father. It's all so wearisome and unnecessary, this exertion to earn our acceptance from God. Even through the look of exasperation Christ's spiritual authority asserts itself. "It isn't long before the roles are reversed: Jesus is the one asking the real question. He is looking into the heart of Caiaphas and revealing his motives, like a searchlight cutting into the darkness. In his humanity the Light of the World is revealed" (Keith White, *Masterpieces of the Bible*, p. 70). Jesus is

saying, "You have said so: I am the Son of God, the one who reveals the heart of the Father of Abraham, Isaac, and Jacob. Do you know him?"

Spiritual Bankruptcy

In the face of Jesus, the rule-oriented approach to relationship with God has its weaknesses exposed. Not only do the embarrassingly obvious ploys of false witnesses and trumped-up charges expose the duplicitous nature of legalism, but Jesus' life and testimony strike at its very heart. He uncovers the shaky foundation of this mindset. He discloses the shallow, bankrupt nature of such a belief system.

Many religious leaders of Jesus' world missed the point of the gospel. Some of Christ's harshest words were reserved for those who could not see the spiritual forest for the trees. Preoccupied with the details, they lost the big picture. "You give a tenth of your spices—mint, dill and cummin. But you have neglected the more important matters of the law—justice, mercy, and faithfulness. . . . You strain out a gnat and swallow a camel" (Matt. 23:23-24).

Fixated with following the rules or playing spiritual calisthenics, we may become too busy to show understanding and express acts of compassion.

Another crippling danger of legalism is its tendency to turn believers into "merit makers." Although we are well-versed and sermonized with the message of grace, our daily habits betray hearts that seem to believe we are made right with God through good and righteous living. Moralism corrupts the gospel. In *The Kingdom Equation*, John Timmer writes,

The gospel says that God's grace always comes first, that coming home to the Father is not an achievement of sorry and humbled sinners, that through the grace of God we already *are* right with God.

But, moralists that we are, we constantly turn things around. We habitually cloud the gospel of grace with a series of "oughts." We think that before the Father will receive us in his favor, we first have to clean up our act and live a better life. . . . Moralism is the sin of reversing the order of the gospel. . . . It presents the Christian faith as an achievement. It turns the Bible into a treasure trove full of suggestions for better living. . . . Moralism corrupts the gospel (p. 48).

Moralism also lowers our view of God. It turns God into someone who demands I reach a certain standard before God can accept me. Following Christ becomes primarily burdensome. All I need to do is follow specific guidelines, and he will be satisfied—like some big brother who needs to be placated or a big sister who sulks and withholds her favor unless I play by her rules and pay her enough attention. Not a high view of God at all. Jesus was plain to point out that following him could be a burden, but such burdens are borne in joy.

A Lawless Gospel?

The relationship Jesus had with the law is an issue that constantly came up in his interaction with religious professionals. Judging from the Pharisees' hostile reaction to Christ, we might surmise that Jesus rejected the law. Nothing could be further from the truth. Hear these words Jesus speaks: "It is easier for heaven and earth to disappear than for the least stroke of a pen to drop out of the Law" (Luke 16:17). Jesus loved the law because it revealed the heart of the Father. He not only loved it, he lived it. Perfectly. He lived not merely the letter of the law but the essence of the law. This was what bothered the contemporary teachers of his day. Notice the quill in *Christ Before the High Priest*, placed on the table beside the book. It points to Jesus, the Word become flesh. Out of his life and teaching come forth the flow of God's Word. Perhaps van Honthorst is using this image to underscore the barrenness of the mere letter of the law in contrast to the living Word.

The Sermon on the Mount, Jesus' commentary on the law, reveals a Jesus who took the law seriously. He went beyond the external and struck at the heart of the matter. Adultery wasn't just about having an affair; it included looking with lust at another and using women as sexual objects. Murder meant much more than ending someone's life; it included using crooked words to damage a reputation and hating in the heart. Does your hand cause you to sin? Cut it off! Does your eye create lustful thoughts? Pluck it out! Obedience not only with the hands and feet but with the mind and heart as well. Anything less than perfect obedience is unacceptable to God.

Jesus is bent on getting it into our hearts and heads that our place before God rests solely on grace. We cannot live the law perfectly; salvation is via another route. The law has not lost its function: it still serves to reveal the nature and will of God; it continues to guide us as a lamp to our feet and light to our path; and when obeyed by God's people, it expresses thanksgiving to God like no other means. But when the law becomes a ladder reaching to the heavens, we quickly find ourselves on precarious footing.

Read through the section of the Sermon on the Mount where Jesus discusses the Law and grace (Matt. 5:17-20). What new insights can you glean from these familiar words?

Cracks In Moral Armor

In this painting, the high priest does not appear too certain of his authority. Caiaphas may have begun to realize that he was wrong about the way of salvation. One of the two witnesses standing behind the high priest is also showing hints of doubt. His head is tilted slightly downward, eyes unable to look directly at the accused. He seems to be having second thoughts.

Dostoyevsky's Grand Inquisitor, after all his questions and accusations have been spoken, his threats of burning at the stake leveled, waits for a word from Jesus.

"The old man [cardinal] longs for Him to say something, however painful and terrifying. But instead, [Jesus] suddenly goes over to the old man and kisses him gently on his old, bloodless lips. And that is His only answer. The old man is startled and shudders. The corners of his lips seem to quiver slightly. He walks to the door, opens it, and says to Him, 'Go now, and do not come back . . . ever.' And he lets the prisoner out into the dark streets of the city. . . ."

And what of the old man? "The kiss glows in his heart . . . but the old man sticks to his old idea." So ends the encounter Ivan's cardinal had with Jesus. The kiss of Christ has an effect on the cardinal's heart, rendering him unable to follow through on his threat of execution. Still, he cannot fully let go of his "old idea," his own attempts to get right with God.

Today, even the most legalistic hearts cannot but wonder about this too. In our heart of hearts, as God's Spirit works, we know legalistic efforts to grant us a place at the foot of God's throne will fail. The closets of our personal history have numerous skeletons hidden from even our closest friends. Unspoken prejudices. Addictions we've managed to keep hidden so far. Hurts we've caused that we're still not sorry for. Premarital sex. An extramarital affair. An abortion we think our parents would disown us for if they ever found out. The way we think we are more important than our neighbor because we are in a higher income bracket or wear better clothes. Who of us can stand up and offer ourselves as an example of right living? A model to be exemplified? No one is perfect. All have sinned. Our best and most prestigious accomplishments, our shiniest trophies placed at the feet of God cannot erase any of it. This we know deep inside. And we know that something about Jesus is different from all this. We know that in him there is another way. The false security we may have based on some legal system cracks once confronted with Christ. He exposes the shallowness, the vanity, the quiet desperation of it all. And he is the one who opens a new way, a way that works, God's way to live.

For all who come to acknowledge this liberating truth, living with God ceases to depend on perfect adherence to a moral code. We still desire to live in serious holiness, following the way of Jesus. Now we can do it with a sense of joy, and even some humor. We can pray this prayer:

Dear God,
So far today, I've done all right.
I haven't gossiped, and I haven't lost my temper.
I haven't been grumpy, nasty, or selfish,
and I'm really glad of that!

But in a few minutes, God,
I'm going to get out of bed, and from then on,
I'm probably going to need a lot of help.
Thank you! Amen.

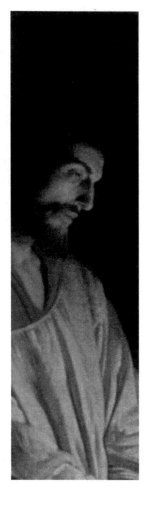

Face-off Winner

As uneasy as this Jesus might make us feel, as hard as it might be to agree with him on all points, as tough as it may be to reject our own will and follow his, we still know he's got it right. His is the way to life. Therefore, the church, which can often seem to be hung up on rules and protocol steeped in traditionalism, is never without hope. Through Jesus' presence among us in the Spirit, we know what "the main thing" is. And that main thing is Jesus. Because he is here, at work in his body, the church will be triumphant. It will prevail and accomplish the mission to which it has been called. In spite of what may at times seem the contrary, legalism will not prevent the body of Christ from proclaiming by word and deed the advance of the kingdom on earth.

The Power and the Glory, a novel written by Graham Greene, tells the story of the church in Mexico during a time of revolution. The church was severely persecuted, the leaders of the revolution seeking to wipe out every priest. The story follows the path of one priest, who eventually becomes the last priest in the country, running for his life. By his own admission, the man is a sorry excuse for a priest.

Finally caught and imprisoned to await execution, his failures flood his mind—pride, a lack of charity, a weakness for alcohol, an endless bad example. . . . Now, the morning of his death, "he felt only an immense disappointment because he had to go to God empty-handed, with nothing done at all." He is taken out to the courtyard and shot, his death marking the end of religion, or so his executioners believe. But the book has one more page. The reader is brought to the home of a family who has befriended priests in the past. There is a knock at the door, late at night. The young son who hears the knock gets out of bed to answer. There a stranger stands and asks for his mother. She is asleep, the son tells the man. "If you would let me come in," the man says with an odd, frightened smile, and, suddenly lowering his voice, he says to the boy, "I am a priest."

Just when church is considered dead and ineffective, another priest appears! Christ's body will prevail and fulfill its mission, no matter the opposition and in spite of the human foibles of its leaders.

Such ultimate victory in the midst of weakness is not easy. Certainly not for Jesus. Just prior to facing Caiaphas, Jesus spent a night wrestling in the dark alone, facing the cup of God's wrath upon the sins of the world. With no help from his sleepy disciples, he submitted: "Not my will, but Thy will be done." Now, before the high priest, Jesus has another opportunity to bow out. Here is the critical question—"Are you the Christ, the Son of

God?" The face-off question with an answer that would determine the fate of humanity. Jesus could have said no and walked. "No, I'm not the Christ." The high priest would have let him go, and the world would have been condemned— lost due to our inability to live up to God's perfect law. But Jesus said yes. In doing so he signed his own death warrant, declaring his resolve to go to the extreme of crucifixion. And he signed our second birth certificate.

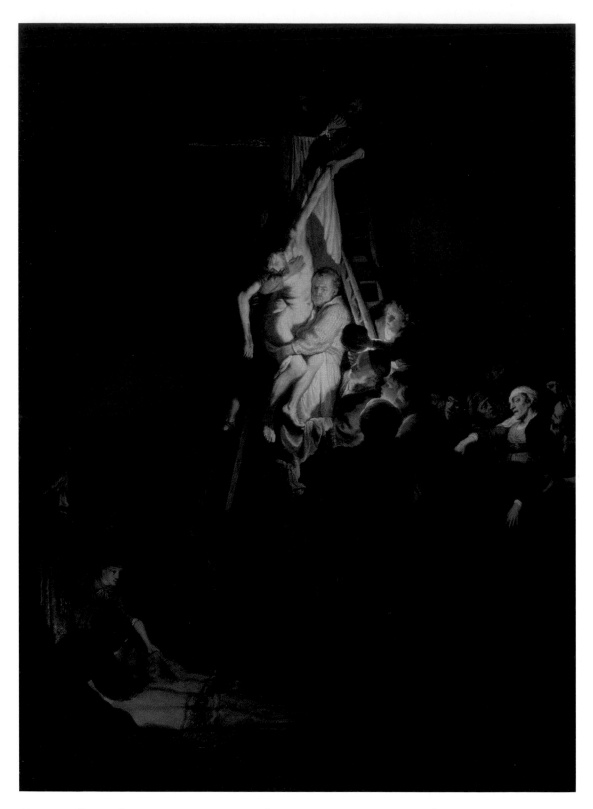

Descent from the Cross ❧ Hermitage Museum, St. Petersburg,
Russia/SuperStock ❧ circa 1634, 158cm x 117cm

CHAPTER 9

૪ઽ

Growth at the Cross

Atrip to the doctor, especially if we know *something* is wrong but can't figure out the cause, is never a welcome ordeal. It likely means we've already experienced pain, and there may be more to come. People have a natural inclination to want to avoid discomfort of any kind. Experiencing physical, emotional, or relational stress? Reach for the Tylenol, or for the remote control, or for the fridge handle, or for the car keys. Don't like the situation you're in? Change the channel, have some food, or go for a drive! Just do something—anything—to remove the pain.

Sometimes, however, suffering is unavoidable. When someone dies, we can't escape the discomfort of grief. The grim reaper will haunt us until we deal with him. The necessity of doing something with the body is also inescapable. That's the painful task that the friends of Jesus faced after his suffering and death on the cross:

> Later, Joseph of Arimathea asked Pilate for the body of Jesus. Now Joseph was a disciple
> of Jesus, but secretly because he feared the Jews. With Pilate's permission, he came and took
> the body away. He was accompanied by Nicodemus, the man who earlier had visited Jesus
> at night. Nicodemus brought a mixture of myrrh and aloes, about seventy-five pounds.
> Taking Jesus' body, the two of them wrapped it, with the spices, in strips of linen. This was
> in accordance with Jewish burial customs. At the place where Jesus was crucified, there was
> a garden, and in the garden a new tomb, in which no one had ever been laid. Because it
> was the Jewish day of Preparation and since the tomb was nearby, they laid Jesus there.
> —John 19:38-42

❧

In an article discussing the changes in his life after he was diagnosed with terminal cancer, Michael Davitt Bell writes,

"My relationships with friends and family—above all my two daughters, now in their twenties, whose mother and I divorced when they were small—have thus taken on an emotional openness and intensity almost inconceivable for someone who, like me, grew up in an upper-middle-class WASP family in the Midwest, a family in which the word 'love' was never spoken or heard except, perhaps, to express admiration for an object or article of clothing ('I just love the way that sweater looks on you!'). So I find I'm not overcome with remorse or anger, or with terror of the fate awaiting me; instead I'm cherishing each moment, each mundane experience I have left. This is, for me, a magic time."

—Michael D. Bell, "Magic Time," p. 40.

Study Rembrandt's 1634 painting after you have read the Scripture. What emotions can you identify in the faces of the people gathered near the cross?

Dying and Living Again

John tells us that the two men who took the corpse from the cross were followers of Jesus in secret. We know from an earlier episode that Nicodemus had visited the teacher from Nazareth under the cover of night for fear of being detected by his peers. Had the Sanhedrin discovered Nicodemus's "unhealthy" interest in the rabble-rousing rabbi, they would have expelled him. He would have lost his position on this esteemed body and even risked being forbidden entrance to the synagogue. So Nicodemus, a prominent member of the organization openly opposed to Jesus, found himself in the tenuous position of being a sincere but closet Christ-seeker.

There was something awfully attractive about this itinerant preacher whom the Pharisees had blacklisted. Nicodemus, like everyone else, was searching for the truth—truth about the human condition and the plight of the suffering, and truth about his personal yearning to be right with God. Jesus seemed to say things and do things that radiated truth about these matters.

"Rabbi, we know you are a teacher who has come from God," Nicodemus had said. And Jesus replied, "Let me tell you

the truth, no one can see the kingdom of God unless he is born again" (John 3:3). Nobody can know truth unless he or she has had a second birth experience, a spiritual opening of the heart. This inextricably involves dying. The old self has to die so the new person can come to life.

Paul Azinger, at age twenty-seven named the PGA Player of the Year, lived for golf and the popularity it gave him. While on the 1993 tour, the chronic pain in his shoulder was diagnosed as cancer. Through the ordeal of sickness and difficult chemotherapy treatments, he lost all interest in golf and in life. He later wrote in his autobiography that it was there, in the pit of suffering and hopelessness, that he met God and was reborn. He was also healed and gradually regained interest in his sport, but with a significant difference. Golf is no longer his whole life—God is. Most interestingly, he says that he enjoys the game now more than he ever did before. In fact, *everything* is much more enjoyable when things are in proper priority. Being alive to God helps the rest of life fall into place.

What impact have times of crisis had on your own faith? On the faith of your loved ones?

Descent into Discovery

Only after Jesus is dead does Nicodemus publicly acknowledge his admiration for this teacher of truth. He comes clean. His actions unequivocally

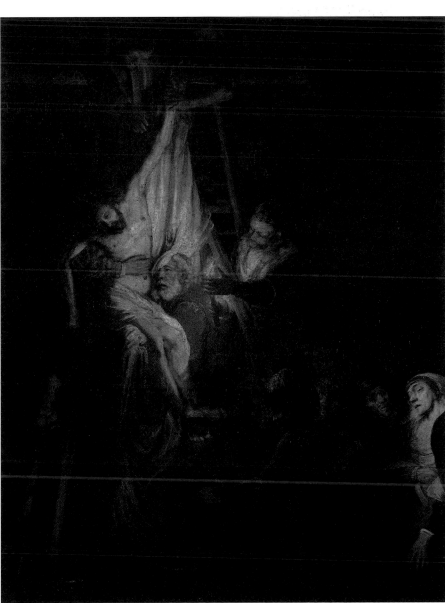

Descent from the Cross Washington D.C., National Gallery of Art circa 1651, 142cm x 106cm

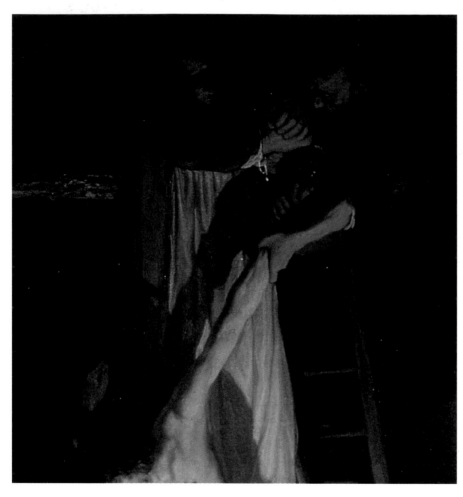

proclaim that Jesus was someone he admired and followed. More than this, the amount of spice he brings to dress the body tells us that Nicodemus believes Jesus was a king who deserved a burial fit for royalty.

In the encounter with death, Jesus' death, Nicodemus discovers spiritual vitality. The crisis in his heart, brought on by Christ's crucifixion, forces Nicodemus to declare his attachment to Jesus. It causes him to come to terms with his relationship with the man from Galilee. Through such a crucible he discovers previously unknown truth about God and about himself. Nicodemus, a Pharisee, takes one giant, precocious step in spiritual maturity and becomes a faith finder.

The crucifixion and burial of Jesus seem to be a place of growing spiritual awareness for Rembrandt as well. He painted this scene several times over the course of his career. In fact, an interval of twenty years separates the two paintings portrayed in this chapter. The spiritual maturation Rembrandt experienced during this time becomes evident as we notice the differences between the paintings.

The earlier painting, created in 1634 (see p. 102), closely follows accepted artistic guidelines and techniques. Overall, it is well-balanced, and the corpse of Jesus is central. Angles and lines are coherent, giving a pleasurable, almost peaceful impression. Rembrandt communicates the sense that everything is under control, given the circumstances. Nicodemus, the figure carrying the weight of the body,

looks emotionally and physically in check. He appears stable on the ladder, arms firmly grasping the corpse. Set jaw and furrowed brow emphasize concentrated determination. His focused eyes express resolution to complete the task at hand.

This general sense of stability is coupled with an element of dramatic flare. Two men perched at the top of the cross are absorbed in the challenge of dislodging the last stubborn nail fixing Jesus to the wood. At the foot of the cross, to the left, are two characters. The one wearing a hooded black cape and peeking around the ladder looks like the grim reaper. The other strikes a pose of exaggerated grief, with overdramatic facial expression and clasped hands, as she gazes at the place where the body will be laid.

Self-portraiture was a common mode of autobiography in Rembrandt's day. The artist, who was prolific in painting self-portraits, has painted himself into this scene as the young man to the left of Nicodemus, holding the torch that helps illuminate the scene. He is involved not merely as an observer, but as a participant in the process of taking Jesus down from the cross. Through this ploy the viewer finds entrance to the thoughts of the painter. We have opportunity to contemplate the meaning this event has for the artist.

Before reading on, compare the two paintings. What differences and similarities can you find? What clues about the artist's faith can you discover in the two paintings?

The second painting, done in 1651, was created after seventeen years of spiritual struggle and journey down the road of life. According to the technical norms of the day, this work is not well-balanced artistically. Although its authenticity has now been credibly established, art experts have at times questioned whether it was in fact an original done by Rembrandt. The corpse of Jesus is not spatially central in the painting, but it holds our attention due to the light. Its physical placement off to the side introduces discord in the mind's eye. Removing the body from the cross is not a pleasant ordeal—it is upsetting and heartrending. The sense of melodrama evident in the earlier work has also disappeared. The two men who, seventeen years prior, were preoccupied with a stubborn nail, are now more involved with the main concern and are carefully, with wondering gentleness, helping to ease the body to the ground. The grim reaper and the melodramatic woman have been excluded altogether.

The sense of control is also skewed. The angles and lines do not fit nicely together, which creates a mood of disarray similar to the actual circumstances. Nicodemus no longer appears young and businesslike. He is not bearing most of the corpse's weight, and appears to be having difficulty keeping his own balance. Is he able to handle this task? His face, older-looking now, has lost its previous set jaw and focused gaze. Now, mouth agape, eyes turned upward, he shows the deep, sorrowful emotion of the moment. He is

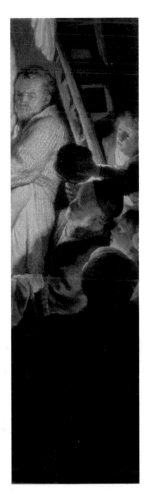

distraught. This undertaking to remove and bury the body of his friend and teacher is taxing him to the limit.

Light and shadow are used to express a relationship between Jesus and the individual holding the torch, who is the artist himself. Both characters share the light; they are related to each other. As Rembrandt pictures himself participating in taking Jesus' body from the cross, it is apparent that he is attached to this crucified man. Especially in the later painting, the torchbearer's facial expression is one of tender love and trusting admiration. The torchlight illuminates a physically mature face that portrays a heart of calm compassion and tentative peace. Religion is primarily about relationships. Jesus is a person with whom Rembrandt had a personal, changing, dynamic relationship.

As the artist aged, the circumstances of his life became increasingly difficult. He lost three children to early death. His first wife, Saskia, died after nine years of marriage. A fourth son, Titus, passed away in his early twenties. Rembrandt encountered financial troubles, virtually declaring bankruptcy, and there is evidence that he and his work lost popularity with the patrons of the art community.

Rather than becoming bitter and resentful through this adversity, Rembrandt grew in gentleness, understanding, and compassion. The paintings he created toward the end of his life reflect this clearly. He set aside the standard restrictions and regulations operative in the art world of his day, not out of rebellion or resent-

ment, but rather to express more accurately the realities of life lived in the context of death, brokenness, trauma, love, and redemptive grace.

The events of life do not always fit together nicely according to the theories and theologies we learn. These two paintings, separated by seventeen years, reflect the artist's growth in the understanding of his mortal life in the presence of a God whose compassion drove him to sacrificial suffering and humiliating death. They reflect Rembrandt's understanding that at the cross we're encouraged to find strength, understanding, new identity, and truth. In proximity to an instrument of death, we discover life.

Think of your own experience with death, brokenness, and trauma. How have these experiences affected your relationship to God and to others?

The Paradoxical Cross

Three times in the gospel of Mark, Jesus specifically outlines for his disciples the path he had to take. On one of those occasions, the devoted but sometimes misguided Peter stands up to Jesus and says, "No way!" Jesus responds, "Get behind me, Satan." Satan did not want Jesus to go to the cross. Anything, any way to distract him and get him off course. The devil knew that for Jesus the way of the cross was the way to redemption and life.

Such reasoning seems preposterous. Illogical to the human mind. Foolish to

Whatever we are by the fall, we must deny or repudiate: our irrationality, our moral perversity, our blurring of sexual distinctions and lack of sexual control, the selfishness which spoils family life, our fascination with the ugly, our lazy refusal to use God's gifts, our pollution and spoliation of the environment, the antisocial tendencies which inhibit true community, our proud autonomy, and our idolatrous refusal to worship the living and true God.

—John Stott, *The Cross of Christ*, p. 282.

the Greeks—how silly to think that a person can live when he or she dies! A stumbling block to the Jews—this is not the sort of Messiah we were expecting! Horrific to the Romans—the cross was the cruellest execution method ever invented by the twisted mind of the fallen human race!

New life is an endeavor requiring hard work. No shortcuts. No easy way. As he walked the earth, Jesus realized that the way to new life would lead to the cross at some point. His mission meant misery. The Old Testament prophet Isaiah was explicit on this score. The suffering servant would be "despised and rejected by men, a man of sorrows, and familiar with suffering . . . pierced for our transgressions, he was crushed for our iniquities . . . oppressed and afflicted, he did not open his mouth; he was led like a lamb to the slaughter . . ." (Isa. 53:3-7). But this is not the end of the prophecy. "After the suffering of his soul, he will see the light of life and be satisfied" (v. 11). Life for Jesus and for all who know him. By his wounds we are healed.

On the one hand, the cross is a symbol of death. It confronts us with the stomach-sinking realization that our old, self-centered egos drove Jesus to such a humiliating end. It follows with denying ourselves and surrendering to the way of Jesus.

But this is not all. Here the paradoxical nature of the cross becomes apparent. Self-denial is not an end in itself—the flip side of self-denial is self giving. The very cross that expresses death also proclaims and affirms

life! Jesus gave himself for us because God loves us. The cross is God's undeniable "yes" to life. The crucifixion stands central in human history as a demonstration of our Maker's life-giving love.

As we bear our own crosses in the form of our own trials and tribulations, we sense God's suffering love with us and we come to rebirth. Giving up the old self, we become the new creatures God intends us to be. Through the Spirit our reasoning power is sanctified, we enjoy healthy bodies, we are aware of moral obligations, we seek to be faithful stewards of earth's resources, we are playfully creative, we love, we experience community, and we are worshipfully aware of our majestic God.

The way of divinely revealed truth says growth in faith can't happen apart from an encounter with the cross. Disciples of Jesus need to grapple mentally and spiritually with what happened on the hill of Golgotha many years ago. Here, at the place of execution, with Nicodemus and Rembrandt and many others, we're called to do our homework. We are confronted with questions: What happened there? Why did it happen? What difference does it make for my life? Get on the ladder. Pry the nails out. Handle the body. Feel the weight. And wonder.

Try to imagine yourself in this scene at the cross as you think about the questions above. On which of the characters in these paintings would you draw your own face? Why?

We are not released from [anxiety and fear] through divine omnipotence of a heavenly Christ. We are released through the very contrary: through Christ's earthly and most profoundly human suffering and fear.

—Jurgen Moltmann, *Jesus Christ for Today's World*, p. 54.

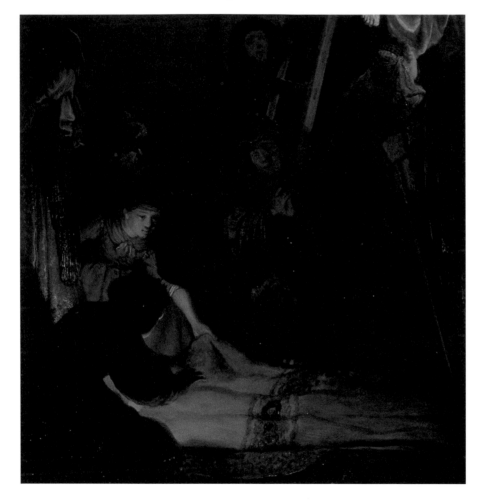

Daniel R. VanderArk, in an issue of *Christian Home and School* magazine, comments that the theory that better self-esteem makes better students and children (eventually adults) is not bearing the fruit proponents of such a theory predicted. Instead of fashioning students who are more tolerant, who study harder, and who are more successful, it has brought forth adults who believe the world owes them a living. He writes, "Self-esteem has become self-indulgence." The fruit of such indoctrination is an "emphasis on individualism and rights which leads to excess, such as parents who 'live for themselves, maximizing their own wealth and pleasures at the expense of even their children.'" VanderArk suggests that self-denial needs to replace self-esteem. "Children need to hear that happiness comes from sacrificing oneself to God, from being adopted as a son or daughter by the living God because of Christ's work, and from giving one's gifts to God in a lifetime of service" ("Self-Esteem," p. 11).

Growing Pains

As an apple tree reveals its growth through blossoms and the bearing of delicious apples, so spiritual growth is gauged by its fruit. Rembrandt's spiritual maturation is reflected in his works of art as he grew in reading and understanding the heart of Jesus. The two paintings picturing the descent from the cross reveal the type of fruit born in a growing follower of Christ.

Recall that the 1634 painting carries a sense of melodrama. In our youth we

hear stories and look for drama. The pitch in the plot is nudged up by our overzealous imaginations. However, those who chronicled the passion of Christ did not do so to arouse sympathy or pity, nor to cater to an errant sense of satisfaction in suffering. The gospel writers wrote to tell and interpret Jesus' ministry and message for their specific audience. Like journalists, they noted the episodes of Christ's life and teachings as they heard them and selected, edited, and arranged them into a coherent written testimony. They do not spare us the details of the last days before Jesus' death; however, they offer these details without resorting to any trace of theatrical flare. Reading the story of Jesus without the superficially heightened sense of trauma portrays the reality of the circumstances more profoundly.

Rembrandt's later depiction of Jesus' suffering, made after numerous years of hardship, reveals a penetrating appreciation for those who suffer. The earlier picture's sense of melodrama expresses the artist's well-intentioned eagerness to pronounce the pain. We get the sense that pain and heartache is an interesting topic for conversation and artistic exploration. In the later painting, suffering is a burden to be shared quietly and subjectively with those weighed down by it. Rembrandt has, during the time between the first and second paintings, entered more profoundly into the suffering of Jesus.

Suffering comes uninvited into our lives. At times it crashes in unannounced and leaves us reeling. Other times it ad-

vances slowly, slithering in, gradually gripping mind or body. It is unwelcome in whatever form it comes. Our instinctive reaction is to run. We don't like pain, and we reach for relief when it visits.

But running from pain isn't always God's way. Instead the Bible encourages us to grow in the very midst of suffering. As we enter into the anguish and hurt of another or experience it ourselves, we meet the seriously suffering Christ. There Jesus visits us in faith. As Job discovered, communion with God reaches new heights in the context of crippling loss. In a way that should never be spoken of glibly, our trials draw us closer to Jesus.

The way a growing Christian reads and comprehends the Bible matures, serving to develop our understanding of Jesus' suffering and our suffering. As we read the *same* biblical passage over the span of our lives, our minds are opened to previously unnoticed nuances. Gems of truth and jewels of wisdom were always imbedded in the text; we just hadn't excavated them yet! We were not able to see them until we had reached a certain level of life experience. When the Word talks of injustice or mercy or suffering, it means more to us now because we've been there. The truth of God's Word resonates more obviously in our hearts; it connects more closely with our daily experience. The correlation between the life of Jesus and our life becomes more apparent to us. According to Rembrandt, the mature Nicodemus is not detached from Christ, but attached—so attached

that it hurts. The earthly life of Jesus gradually embraces us deeply. Our Savior gets into the far reaches and hidden places of our minds and hearts. This is God's story, and it is our story. Divine action and life experience intersect more regularly in our daily life.

Read the prophecy of the suffering servant from Isaiah 53. What new understanding can you glean from it? How has your own experience with suffering affected your understanding of this passage?

Once, a missionary said he learned a valuable lesson from the people he was reaching. They did not pray, "Lord, take this burden from me." They prayed, "Lord, make me strong to bear this burden." A growing follower of the crucified Christ asks the Spirit not to lead us around the trouble but through it.

Nicodemus was at the cross. Rembrandt visited there too, involved in the burial of Jesus' body. The heartaches of the artist's life could only make sense in the context of the beaten body of Jesus on the tree. These heartaches not only made sense—they caused him to know God like nothing else could.

Were you there? Are you there, growing, at the cross?

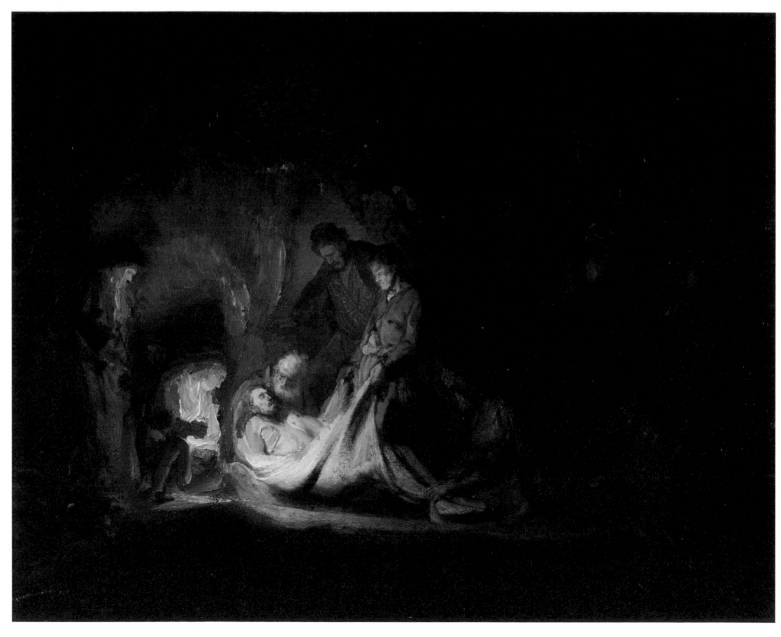

The Entombment of Christ 🙰 Hunterian Museum and Art Gallery, University of Glasgow 🙰
circa 1639, 32cm x 40cm

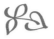

Mysteriously Beautiful Death

Late in the summer of 1997 the world experienced the deaths of two celebrated women. Lady Diana, Princess of Wales, was killed in a tragic car accident; Mother Teresa, the indefatigable nun who served the poor in Calcutta for decades, passed away at the age of 87.

Their deaths caused a wave of sorrow to circle the globe. We were stopped in our tracks by the sudden interruption of death.

Death has a way of abruptly turning us into unwilling spectators. We can do nothing to stop it. Watching helplessly, all we can do is respond to it. And we all react to the experience of death in different ways. John Donne's defiant response was, "Death, be not proud, though some have called thee Mighty and dreadful, for thou art not so." The author of Ecclesiastes appears resigned to death's permanent place under the sun: "There is a time for everything . . . a time to be born and a time to die" (Eccles. 3:2). Samuel Beckett's Pozzo (*Waiting for Godot*) reflects, "They give birth astride a grave, the light gleams an instant, then it's night once more." And Shakespeare commented that life is like an actor on a stage, "The way to dusty death. Out, out, brief candle! Life's but a walking shadow, a poor player, That struts and frets his hour upon the stage, And then is heard no more . . ." (*Macbeth*). Death stops us in our tracks, forces us to watch involuntarily, and changes us.

Think of your personal experiences with death. What changes did those experiences make in the way you perceive life? In your relationship with God?

This painting, created in 1639 and displayed in Hunterian Museum in Glasgow, Scotland, is actually a monochrome sketch that Rembrandt created to make an etching which, as far as we know, was never produced. A monochrome is a painting produced with shades of a particular color.

When we are confronted with Jesus' death, we become, to a degree, sideline spectators. He suffered on the cross. His body was taken down, wrapped up, and laid in the tomb. We're helpless to change any of this. We are mere witnesses. This is not to say we do not benefit from watching. We do! In fact, precisely by looking closely and seeing clearly do we find, or at least begin to grasp, the purpose of Jesus' death and burial. In *The Entombment of Christ* Rembrandt helps us view the death and entombment of Jesus. As we look closer, we read Mark's report of this scene.

It was Preparation Day (that is, the day before the Sabbath). So as evening approached, Joseph of Arimathea, a prominent member of the Council, who was himself waiting for the kingdom of God, went boldly to Pilate and asked for Jesus' body. Pilate was surprised to hear that he was already dead. Summoning the centurion, he asked him if Jesus had already died. When he learned from the centurion that it was so, he gave the body to Joseph. So Joseph bought some linen cloth, took down the body, wrapped it in the linen, and placed it in a tomb cut out of rock. Then he rolled a stone against the entrance of the tomb. Mary Magdalene and the mother of Joses saw where he was laid.

—Mark 15:42-47

What new insights into Mark's account can you gain from studying Rembrandt's portrayal of these events? Where does the painting focus your attention?

Looking for Kingdom Life

Mark tells us that Joseph of Arimathea was waiting for the kingdom of God. The word *waiting* intimates a sense of searching, expectant longing. Rembrandt has keyed into this dynamic in Joseph's heart. As we consider the painting, our eye is attracted to the two faces that form the artist's central focus—the dead face of Jesus and, a few inches away, the face of Joseph. Joseph's face seems to be transfixed by Christ's lifeless features.

Joseph's mind is totally absorbed—not only with the task at hand but also with the sudden reality that Jesus is dead. This death is a mystery to him. He knows Jesus is dead because he sees the ashen face right in front of his own. And yet, there is something about this death—much, in fact—that doesn't make sense to him. You see, Joseph was searching for the kingdom. He thought Jesus was the one to bring it, but now this Jesus is dead, and Joseph's not quite sure whether the kingdom has actually come, as Jesus said it would.

The kingdom was the hope of the Jewish people. They had had a taste of the glorious kingdom of God in the reigns of David and Solomon years earlier—glory days of old when the Israelite nation was feared on the face of the earth for its God and its power. Hebrew history goes on to record the sad story of how all this disappeared through disobedience, idolatry, and humiliating exile. Then prophets began to see visions and tell of days to come when the kingdom would be

restored. Indeed, a time of peace, shalom, would come that would surpass the peace of even King David's reign. No more poverty, no more hungry children, no more widows abused by the system, no more crooked tax practices. One gets dizzy with such thoughts! And it was all to come through another king—a Messiah. Mark tells us that Joseph, a religious leader in the community, was eagerly waiting for this Messiah who would announce the arrival of the righteous rule of God.

Then it happened. This man from Galilee started going around preaching that the kingdom of God was at hand. Jesus sat in the temple one day and read the words of Isaiah: "The Spirit of the Sovereign LORD is on me, because the LORD has anointed me to preach good news to the poor. He has sent me to bind up the brokenhearted, to proclaim freedom for the captives and release from darkness for the prisoners, to proclaim the year of the LORD's favor . . ." (Isa. 61:1-2). Then he calmly explained that the day had come. He was the chosen one.

He backed his words up with deeds too. The lame walked, the blind had their sight restored, the poor were lifted up, the outcast found forgiveness in his presence, and crooked people changed their ways once they encountered him. He spoke with authority, calling a spade a spade. He cut through the falsehood, often attacking the practices of the religious council that Joseph was a member of. Even these attacks, strangely enough, attracted Joseph

⁊⳽

Calvin Seerveld spares no punches as he describes the insidious nature and ruinous effects of sin.

"We are prone to sin—never mind about the other person. We pontificate in God's face. We covet power and authority and cover it up with a 'for the glory of God.' We are splitting up a confessional communion while the world goes to hell. . . . We are as bad as Pharisees, Sadducees, and misled people in Christ's day over whom Jesus wept because their biblical vision of service to the world was dying (Luke 19:36-46). From the beginning, God knew how satisfying sin is to humans—for a while. God also knew how sin boomerangs with ruin, and God knew the helpless, frustrated vanity and impotence that can follow."

—Calvin Seerveld, "The Fall Demanded Christ's Sacrifice," p. 18.

to this wandering preacher. As Jesus' word got out, it increasingly caught the attention of the community leaders, both political and religious. Things were beginning to happen in a significant way. Jesus came riding into Jerusalem followed by crowds going berserk with eager expectation. Any day now he would make the big move and set up the kingdom!

Where do we see the coming of God's kingdom today? Does it sometimes disappoint you too? Why?

Then something else happened instead. Jesus died. It all came about so quickly— so swiftly and unexpectedly. Joseph's colleagues on council got all riled up about the things Jesus was saying. Blasphemy, they said it was. They convinced the crowd. Got the Romans involved. Some questionable charges were laid, and Jesus was hastily put on trial and condemned in an unofficial way. The judge washed his hands symbolically and said, "I'm not taking responsibility for him; he seems innocent to me. You do with him what you want!" Then, before any sanity could prevail, Jesus was hanging on a cross. Executed.

Finding Kingdom Death

Now the dust had settled a little, and Joseph asked for the body. As he wrapped Jesus in linen cloth, his heart compelled his eyes to look earnestly into the face of this man who was supposed to be King. Questions plagued his mind: Was this

Jesus the one? If he was, it wasn't supposed to end like this, was it? Was this any way to build a kingdom? Set up rule? It just didn't seem the way to go.

Yet, Joseph's face, according to Rembrandt, portrays more than wondering despair. His facial expression is not one of uncomforted grief and unrestrained sorrow. It holds a tentative calm. A sense that this dead body held hope, even in this state. Hard to explain—mysterious, yet real. Maybe, just maybe this was the way it had to go. Maybe it wasn't one big mishap after all. If memory served correctly, Jesus had talked of dying. Just because nobody wanted to hear that part or pay attention didn't mean he didn't say it. And his demeanor during the trial seemed one of resolve. There was an uncanny sense of certitude in the way he faced the injustice. It was as if he knew it had to go this way. That this, in fact, was exactly the way the kingdom was going to come.

Joseph did not have the advantage we have. We live hundreds of years after he did. We have the luxury and insight of literally thousands of books, Bible study guides, sermons, church history, and teaching that interpret the death of Christ in hindsight. Jesus *had* to die. Sin required it. Nothing less than sacrifice would counteract the alienating effects of disobedience. This was the only way for us to be brought back into fellowship with God.

God needs to take sin seriously. And doing so means someone has to suffer

and pay the price of death. Our world perceives the penalty—sin lays waste to God's good creation, breaks up families, afflicts bodies with wounds and disease, corrupts society, and leads us toward death. However, in love God intervenes and halts complete carnage, paying the death penalty himself. "We have been made holy through the sacrifice of the body of Jesus Christ once for all" (Heb. 10:10). The perfect sacrifice of God's Son on the cross erases our guilt forever. The consequences of our waywardness would boomerang back upon us and leave us permanently outside the kingdom. Instead God intercedes, dumping the ruinous effects of sin on his Son.

So Jesus dies. He had to or we would never experience God's gracious reign. We have heard this before—it's the Good News! Joseph of Arimathea did not have the benefit of Paul's epistles or Calvin's commentaries. So Rembrandt pictures him looking with mystery into the face of Jesus—wondering how such a brutal death could serve as the means by which God would establish his rule on the earth.

But there is more. Rembrandt invites us to reflect beyond the explanation of Jesus' death for the removal of our sin. He challenges us to see the kingdom coming. Still more, he calls us to see the beauty of this kingdom. Where does the artist beckon us to look for this beauty? In the most unlikely place: the face of our dead Lord. It sounds ludicrous. A term like "beautiful death" qualifies as a perfect oxymoron.

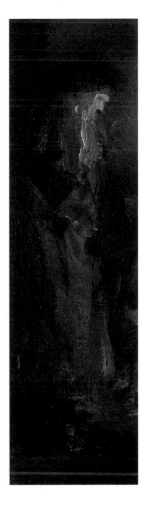

Can death ever be beautiful, even under the most favorable conditions? Explain.

Beautiful Death?

Roger Rosenblatt, in an essay about the untimely death of Lady Diana, Princess of Wales, stated, "She was beauty, death's antithesis. Beauty is given not only a special place of honor in the world but also a kind of permanence, as if it were an example of the tendency of nature to perfect itself, and therefore something that once achieved, lives forever" ("Beauty Dies," p. 60). Later in the article he laments that his wish for permanent beauty is to be denied. Beauty dies. He ends the piece by saying the most memorable picture Diana left us is her wedding day, "when all the world was glad to be her subject and when she gave everyone who looked at her the improbable idea that life was beautiful." Even life, he laments, is not beautiful. Rembrandt seems to take issue, arguing that not only is life beautiful, but death can be too!

When we view the painting initially, it's difficult to see that beauty. Commentators on the painting say that the characters witnessing the burial reflect various emotions. "Their emotions are conveyed in their attitudes and facial expressions, as they dwell in quiet depression over Christ's dead body" (J. Bolten, H. Bolten-Rempt, *Rembrandt*, p. 89). And Gary Schwartz, another Rembrandt scholar, writes this telling note: "The *Entombment*

had been in the restoration laboratory of the Alte Pinakothek in Munich for several years when I saw it there in spring 1983. The chief restorer, Dr. H. von Sonnenburg, told me that his staff could only work on it for so long at a time before growing too depressed to continue" (*Rembrandt, His Life, His Paintings*, p. 117). Unquestionably, the painting serves as a poignant expression of feelings that accompany those who are spectators of death. But beauty?

It is impossible to talk about the idea of beauty and not ask the question "What is beauty?" How would we define it? Nicholas Wolterstorff summarizes the popular view of beauty, saying, "A beautiful object was taken to be one whose parts fit together consonantly or harmoniously, which has a certain brightness or brilliance about it, which has a certain integrity or perfection about it, and which is pleasant to contemplate" (*Art in Action*, p. 162).

When set up against that definition, death fails the "beauty" test miserably. Death does not bring harmony but discord, it is not bright but ominously dark, it is not perfect but rather the ultimate symbol of an imperfect world, and it is definitely not pleasant to contemplate. However, in characteristically maverick fashion, Rembrandt seemed to move the idea of beauty from the philosophical (abstract) to a more spiritual, experiential realm. He saw the world as the careful creation of a very imaginative and colorful Creator. Beauty was everywhere.

The artist is a man who is trained to see and go on seeing . . . this is one of the artist's most difficult tasks and one which anyone interested in art must try to follow. The artist must be able to see old boots, or anything else, as form apart from its associations. He must see that beauty and perfection must be striven after, so that a subject that is not beautiful may be turned into a work of art. This requires thinking as well as feeling.

—Bernard Myers, *The Book of Art: How to Look at Art*, p. 93.

Today we find standards of beauty in glossy magazines or walking down the fashion runways in Paris. Rembrandt's idea of beauty penetrated beyond the superficial, skin-deep standards of our culture. The artist had the gift of seeing inner beauty. Physically, Rembrandt was not an attractive man himself. H. Perry Chapman, one early biographer, said of his appearance, "To Baldinucci we owe the indelible image of Rembrandt with an 'ugly and plebian face'" (*Rembrandt's Self-Portraits*, p. 132). Another author described him as having a "potato face." Perhaps these personal "defects" aided him in seeing beauty that went far beyond the external—a spiritual beauty, visible to the eye, which viewed the world as God's careful and loved creation.

Andries Pels, a seventeenth-century poet, writes this about the artist:

He chose no Greek Venus as his
 model
But rather a washerwoman or treader
 of peat from the barn
And called this whim "imitation of
 nature."
Everything else to him was idle orna-
 ment. Flabby breasts,
Ill-shaped hands, nay, the traces of
 the lacings
Of the corselets on the stomach, of
 the garters on the legs,
Must be visible, if Nature was to get
 her due:
This is his Nature, which would
 stand no rules,

No principles of proportion in the
 human body.
—H. Perry Chapman, *Rembrandt's Self-Portraits*, p. 132.

This poem, meant to chastise the artist, in fact compliments him in a backhanded way. He painted the world in which he lived as he saw it—people with crooked noses, wrinkled skin, and gnarled fingers; homeless street people sitting on the curb, and mongrel dogs marking their territory. Rembrandt painted not strictly as a realist, but as one who perceived the inherent aesthetic wonder of God's real and physical world. With humble respect we may postulate Rembrandt's working theory of beauty as such: the supernatural work and presence of God in the everyday circumstances of life. No, we do not live in a perfect world. Death and darkness are ugly, and Rembrandt did not deny this reality. However, everywhere God was at work, infiltrating always, infusing with grace and light. This was beautiful for Rembrandt.

Think of some examples of signs of God's grace and light in some of the ugliness of our world. Remember a time when you saw beauty in circumstances that most people would call dark or depressing. How does faith give you new eyes?

Such an understanding explains how Rembrandt is able to picture Joseph gazing intently into the dead face of Jesus and detecting something mysteriously beautiful. In the face of Christ we do not

Our nearness to God himself brings his splendid creation to us in technicolor.

—Abraham Kuyper, with James C. Schaap, *Near Unto God*, p. 127.

❦

James "Buck" Hatch, Presbyterian pastor and professor of pastoral care at Columbia Bible College, serves as an example of one who saw the beauty of God in the most unlikely places. James Hatch's son observed the following near the end of his father's life:

"He has naturally gravitated to 'little' people, the ungifted, the unattractive, those often regarded unlovely, or troublesome, or unuseful. . . . His bedrock conviction was that God is far more reliable, faithful, and forgiving than his people imagine. His purpose was, as Augustine put it, to 'restore to health the eye of the heart whereby God might be seen.'"

—Nathan Hatch, "The Gift of Brokenness," pp. 34-35.

see a face racked with pain or torture, as we might expect in one who just died on a cross. Jesus' face itself, even as a lifeless one, exudes a peaceful calm. He is at rest. His mission is accomplished. The heavy burden of the world's sins on his shoulders has been taken care of. The cup that has been drunk to the final dregs, is now empty and cast aside. Sins are removed. Salvation is accomplished. The way into the kingdom is open. Jesus has in fact established the kingdom on the earth. Not a kingdom the eyes of the world would have—one with beautiful palaces of jewels and gold with perfectly proportioned queens and handsome kings. No, rather a kingdom ruling with spiritual laws of grace, justice, peace, righteousness, love, and forgiveness. In time this rule would infiltrate every last corner and realm of earth and heaven. As Joseph contemplates the mysterious face of the corpse of Christ, we sense his subdued wonder and gradual realization that Jesus has brought the rule of God to earth.

Beautiful Sight for Sore Hearts

Christ followers take on kingdom vision—vision that resides in the eye of the beholder as much as in the object viewed. We begin to see progressively more of the beauty of the world in which we live.

The light of Christ that has infiltrated our hearts in turn impacts our vision of the world we live in and the things we see. Abraham Kuyper encourages us to "live gloriously in a creation that is immensely

brightened by [our] knowledge of God. What's important to remember is that everything we see around us looks different as a result of our knowledge of the Father through the Son" (*Near Unto God*, p. 127).

We see beauty all around: In evening grass lit up by a setting sun. In a hearty laugh, a good conversation, an adult baptism. In the fresh smell of an early summer morning. We feel beauty in a cleansing shower. We hear it in the mildly melancholic notes of an oboe solo or in the trumpet solo in Handel's *Messiah*. We experience it in the weight of a three-month-old baby snuggled against our breast, in a job well done, in a sanguine mood. We feel beauty in a palm against the flank of a horse. We're aware of it in the aroma of supper after coming in from the winter's cold, in the warm words of a spouse, in vespertine light. We see it where earth meets heaven at the distant horizon. In cloud shadows on a green hillside. Through the hard-working, oft-neglected human foot. Through fingers working in harmony. We discover beauty in the smell of freshly turned soil. In the shade of an oak tree. In a John Constable landscape painting. In Jan Vermeer's *The Milkmaid*. Through the sound of skates on ice. In an endless expanse of blue sky. In the first snowfall, a questioning glance, a knowing smile. Through the pensive face of an old man, the mature voice of a woman, the laughter of a child, the intricate design of an ear, a toddler's first steps. In a sparkle in the eye, the intricate Krebs

cycle, the way of the lung, the quiet of a winter mid-afternoon, the dancing aurora borealis. Through the Milky Way, hues of blue in a winter's dusk. In a boundless desert sandscape, a sundrenched crop of blooming canola, the work ethic of the ant, the flight of an eagle, a soft breeze on the face. Through holding hands. In the sound of a cappella voices in harmony. Through the orange glow of embers. In fond memories, white sails on the water, a burst of color, an open-air farmer's market. Through a fragrant lilac, an old hymn sung without restraint, a story well told, a ballad well sung. In infant baptism, words of wisdom, a promise kept, a commitment honored, a life lived by grace.

Look around you and make your own list of beauty we often take for granted.

In faith we see God at work in all of it. Even in the place of death, a funeral. Death turns us into helpless spectators. We'd best not downplay the awful reality of the grim reaper. It can and does bring us to tears of sorrow. It forces us to stop whatever we are doing and look at it. But not so for the Author of life. Death causes God to spring into action. At the grave God has not abandoned us. In this place too God works with beauteous, mysterious redemption. In the life and face of Jesus, we sense beauty, even when affronted with death.

Mother Teresa's death caused the world to stop and take note. People everywhere knew of her faith and humble works of

charity to the poorest of the poor. One of her trademark sayings was that she was ministering to Jesus as she served the poor. She saw "Jesus in their eyes and treasure in their souls" (Subir Bhaumik, "Seeker of Souls," p. 66). In lepers, AIDS patients, the dying, and the homeless she heard Jesus saying that in giving to the least of the earth, she was giving to him. As she looked on them, she sensed the beauty of Christ. The guiding theme of the organization she founded, the Missionaries of Charity, is "Let every action of mine be something beautiful for God" (Bhaumik, p. 68). Mother Teresa's death causes us to ponder such things.

Rembrandt seemed to have a heart whose eye saw the hand of God at work persistently. He looked for beauty in the most unlikely places—even as a helpless bystander in the event of death's unwelcome intrusion. *The Entombment of Christ* boldly proclaims the victory of God in the face of death. The tomb, cut out of the rock hillside, does not appear dark and foreboding. Instead it is flooded with light. In the very place of death and decay God is present. And there God brings life. Ironically, the corpse of Christ testifies to this truth. The mystery of Jesus' death proves beautiful according to the wondering expression on Joseph's face. It brings the beauty of the eternal kingdom to our world.

———————————

We remember the death of Jesus each time we participate in the sacrament of communion. Next time you hold the piece of bread and the cup of wine and hear the words, "This is my body, this is my blood," visualize Rembrandt's portrayal of Jesus being buried. (You may want to ask your pastor to put it on a transparency and have the whole congregation view it as you remember.)

———————————

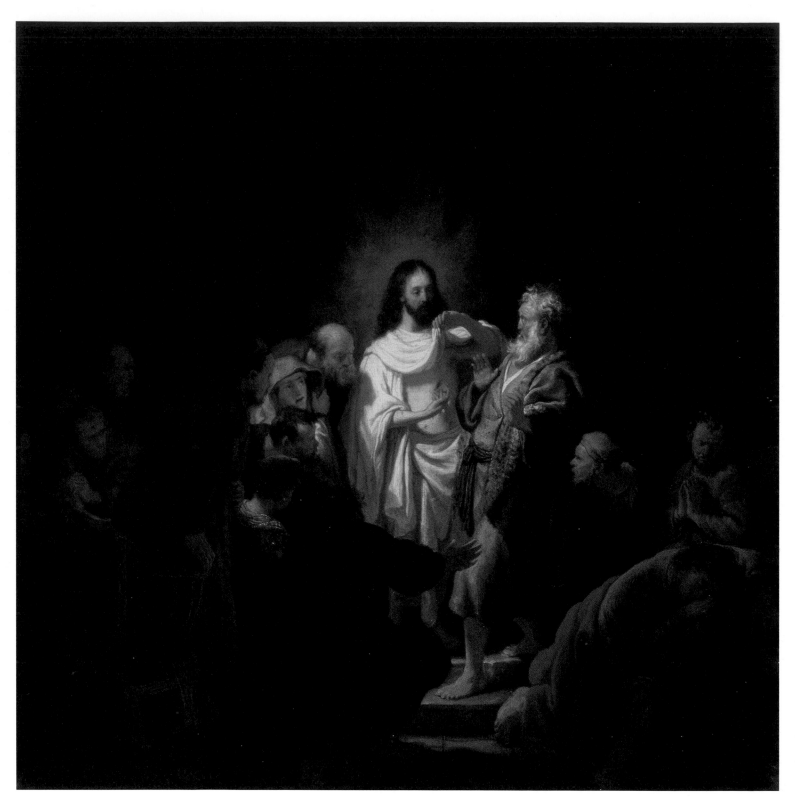

The Incredulity of St. Thomas ❧ Hermitage Museum, St. Petersburg, Russia/SuperStock ❧ circa 1634, 50cm x 51cm

Incredible Life

Do you remember the last time you were surprised?

There is a story about a commercial airline pilot who was always feeling tired. He mentioned this to a flight attendant one day, and she told him that perhaps he needed a healthier diet. This made sense to him. His family was conscientious about eating well and had unsuccessfully admonished him to do likewise. He was willing to give it a try. One morning he got up early, bleary-eyed and sleepy. He went to the pantry, picked out a box of 100 percent natural high-fiber cereal, and began to munch away reluctantly. When his wife came into the kitchen, he couldn't resist muttering, "This stuff tastes awful! How can you stand eating it?" Looking at his bowl, she did her best to suppress a grin and said, "We don't eat *that!* That's the hamster food." It was enough to shock him wide awake!

Most of us don't mind being surprised once in a while. It's fun, usually. But being shocked or scared is another story. Rembrandt painted Thomas's shocked reaction to Christ's post-resurrection appearance in *The Incredulity of St. Thomas.* The disciple's face, hands, and posture convey his reaction to his encounter with Jesus. The one who was given up for dead and laid in a tomb days earlier is now alive. Incredible news! *Incredible* in the true sense of the word—so extraordinary it seems impossible. The dead do not come back to life.

Thomas had had a little trouble believing the earlier report of the disciples. He had wanted evidence. Now the evidence stares him in the face, and he's in shock.

The painting expresses the ambiguities of this remarkable situation. The artist, having read John's story of the two separate encounters Thomas had with his fellow disciples (the

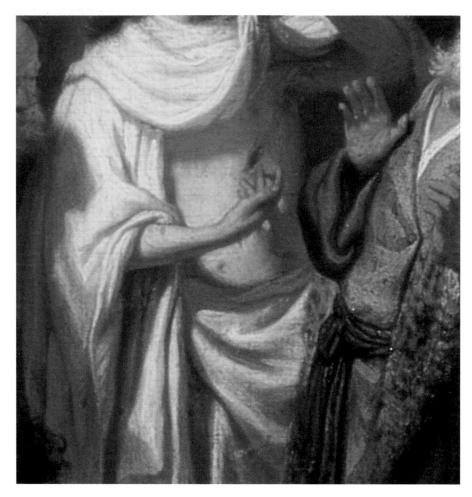

first without Jesus and the second one with him) includes both in one work of art. The painting not only captures the moment of revelation and belief for Thomas, but also includes some of his history as one who struggled with doubt.

Now Thomas (called Didymus), one of the Twelve, was not with the disciples when Jesus came. So the other disciples told him, "We have seen the Lord!"

But he said to them, "Unless I see the nail marks in his hands and put my finger where the nails were, and put my hand into his side, I will not believe it."

A week later his disciples were in the house again, and Thomas was with them. Though the doors were locked, Jesus came and stood among them and said, "Peace be with you!" Then he said to Thomas, "Put your finger here; see my hands. Reach out your hand and put it into my side. Stop doubting and believe."

Thomas said to him, "My Lord and my God!"

Then Jesus told him, "Because you have seen me, you have believed; blessed are those who have not seen and yet have believed."

—John 20:24-29

As you study this painting, take time to reflect on your own times of doubt. Which people, events, or circumstances have triggered doubt and skepticism in your life? Which people, events, or circumstances have helped your faith triumph over doubt?

Doubting Thomas and Company

We should not be too hard on Thomas. He was not skeptical due to lack of love or devotion. Earlier in the gospel of John we are told of his commitment to Jesus. Thomas, believing Jesus had just explained that he was on a path that would lead to death, encouraged the other disciples by saying, "Let us also go, that we may die with him" (John 11:16). He was willing to go all the way for his master.

Thomas is actually the type of player you want on your team. When the chips are down, you can count on him to be there and put his whole heart into the effort. His commitment is beyond question. This disciple was a staunch supporter of Christ's plan. Naturally he was distraught and disappointed when Jesus was traumatically put to death. So when the others told him, a few days later, that Jesus was not dead but alive, it sounded like some cruel hoax. "April Fools' is over, guys. This is no time for a prank."

Can we blame him? Isn't it easy to share in some of his skepticism, even today, after the evidence of a resurrected Jesus has been made clear to us? Pastor and writer Frederick Buechner writes, "Whether your faith is that there is a God or there is not a God, if you don't have any doubts you are either kidding yourself or asleep. Doubts are ants in the pants of faith. They keep it awake and moving" (*Wishful Thinking*, p. 20). Doubt is an inevitable reality when believing in an entity we cannot see with the physical eye. By its very nature, faith includes the possibility of doubt. All people of faith hold company with Thomas on this score.

Doubt should not be mistaken for unbelief. Where unbelief is a stubborn refusal or rejection of faith, doubt is a wavering between unbelief and belief. A word study of New Testament words translated as *doubt* indicates the sense of being of two minds, and that's what we detect in Thomas. He seems to want to affirm, to believe with his whole mind and heart and actions, but he is hampered by the nagging thought that this just might not be true. He is being honest in the face of the incredible news that his friend Jesus has been brought back to life. After all, it isn't every day that dead people walk out of their graves and back into your life.

Doubt is no fun. We do not plan to have a season of doubt because we feel it would be good for our faith life. No, it comes and bothers us, confronting us with the real possibility that what we hold as true may not be in the end. Unwelcome, it comes and asserts its penetrating questions:

- If there is a good and powerful God, why do children suffer and die?
- If the God of the Bible is the only true God, how could millions of other people who embrace Hinduism, Buddhism, and Islam all be wrong?
- What about my colleague at work who is not a Christian and yet lives an exemplary life, volunteers for the community generously, and

The heart of doubt is a divided heart. . . . Genuine faith is unreserved in commitment; doubt has reservations. Faith steps forward; doubt hangs back.

—Os Guiness, *God in the Dark*, pp. 23, 25.

⁊ᔕ

The Russian novelist Dostoyevsky wrote a book called *The Devils* that is preoccupied with the question of God's existence. The characters constantly ask themselves and each other whether they believe in God and discuss the implications of their beliefs. Two of these characters are Shatov and Stavrogin. One conversation (p. 259) goes like this:

Shatov: "To cook a hare—you must first catch it; to believe in God—you must have God . . . "

Stavrogin: "Tell me, have you caught your hare, or is it still running about?"

Shatov: "Don't dare to ask me in such words! Use others, others!"

Stavrogin: "By all means I shall put it differently. . . . All I want to know is whether you believe in God yourself."

Shatov: "I believe in Russia. I believe in the Greek Orthodox Church. I—I believe in the body of Christ. I believe that the second coming will take place in Russia. I believe . . . "

Stavrogin: "But in God? In God?"

Shatov: "I—I shall believe in God."

enjoys a relatively happy home? Compared to him, some of my Christian friends look self-serving and prejudiced.

- Why is it so difficult to make progress towards Christlikeness in my life? At times the transforming power of the Spirit we talk about seems nonexistent. Are all the words of God's renewing work nothing more than empty talk?

Add your "doubt" questions to the list. What things raise doubt in your heart?

Such weighty queries are not for playing games. Although doubt isn't the same as disbelief, there is a connection. And if we allow doubt to continue unchecked in our life, it can gradully eat away at the core of our faith. Doubt should not be taken lightly.

However, doubt need not lead to unbelief either. When we address doubt seriously, it leads to reaffirmation of faith. "If ours is an examined faith, we should be unafraid to doubt. If doubt is justified, we are believing what is clearly not worth believing. But if doubt is answered, our faith grows stronger still. It knows God more certainly, and it can enjoy God more deeply" (Os Guiness, *God in the Dark*, p. 14). Jesus took Thomas's doubts seriously. He recognized his disciple's desire to have a faith firmly grounded in reality. This man wanted to believe in a God who was worth believing in.

Where's the Beef?

For us to believe in something, we need to have reasonable grounds for truth—some assurance that what we confess is not, in fact, a bunch of hot air. How cruel it would be to base a life on a system of beliefs that ultimately turned out to be smoke and mirrors! Imagine living your life trusting in God, praying to God, and serving God. Then you die, only to find that there is no heaven, no new earth, and no one who is called God. It was all one huge fairy tale!

Thomas is not interested in such fairy-tale theology. If he is going to believe Jesus is alive, he wants to have hard evidence on which to base such trust, not a faith that evaporates at the first tough question that comes along. Do we want anything less? The apostle Paul states, "If Christ has not been raised, your faith is futile: you are still in your sins. . . . If only in this life we have hope in Christ, we are to be pitied more than all men" (1 Cor. 15:17, 19). If there is no historical resurrection, then there is no Christianity.

We not only desire reasonable grounds on which to found our faith, we also *want* to believe. When asked if he believed, the beleaguered father of the demon-possessed son proclaimed in exasperation, "I do believe, help me overcome my unbelief!" (Mark 9:24).

We want to believe in God. We want to trust that Jesus of Nazareth was God incarnate. We want to believe this Son died on a cross for our sin. We want to believe that he rose from the dead to give victory over the grave. But our minds and hearts demand that we have reasonable evidence on which to ground those articles of faith. "Unless I see the nail marks in his hands and put my finger where the nails were, and put my hand in his side . . ."

He Really Is Back

The gospel details make it clear that originally the followers of Jesus did not expect him to rise. The disciples hid and locked themselves behind heavy doors for fear of the authorities searching for them, accusing them of stealing the body. They hadn't taken it, but they were not sure who had! Women had gone to the tomb early Sunday morning with spices, fully expecting to dress a decaying body. After being shocked to find the body gone and told that Jesus was not there but had risen, they went to report to the disciples. The disciples dismissed the women's news as old wives' tales. Only solid evidence would convince the disciples that Jesus had, in fact, risen.

Jesus provided such evidence. He appeared to them in the room as they huddled together. He walked with and instructed two disciples on the road to Emmaus. They touched him. He ate fish before their eyes. In the forty days he spent on the earth after his resurrection, Jesus appeared to over five hundred people (1 Cor. 15:6). Not a select one or two, or even twenty or thirty, but more than five hundred.

Ironically, another piece of evidence supporting Christ's resurrection is the

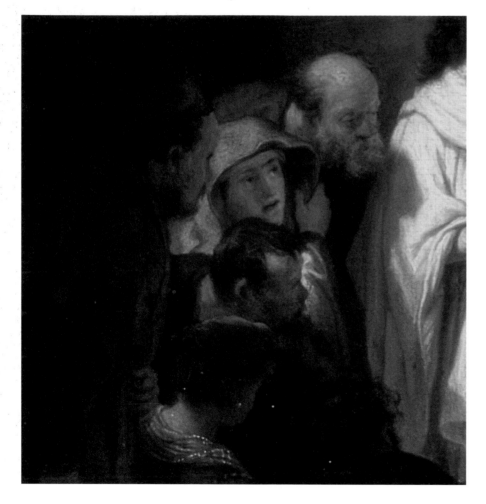

disciples' initial disbelief. They never really expected him to come back. Their bold proclamation of his resurrection, their willingness to die for this truth, and the subsequent establishment and growth of Christianity can only be explained by the contention that the disciples had been completely convinced that the resurrection had, in fact, happened. The English journalist Frank Morison wrote a book called *Who Moved the Stone?* Originally he had set out to discount the resurrection as fiction created by overzealous minds. After looking closely at the evidence he was convinced and converted to believe in the historicity of Jesus' resurrection.

Thomas could deal with doubt by physically meeting with Jesus. How can you deal with your doubts?

It is this kind of doubt followed by belief that *The Incredulity of Thomas* focuses on. Rembrandt envisions the reactions of a doubter confronted with the truth. Head thrust back, eyes wide open, brow raised, and hands spread apart. His body is thrust back on his heels, as if pushed back by a sudden, unexpected blast of air. Thomas's posture and facial expression deftly reflect the complexities of what must have been going through his mind at the moment of revelation. Doubt is being dramatically confronted with the facts it sought. The gears of Thomas's mind are turning furiously in attempt to process this latest revelation.

Some Believe, Others Don't, and Still Others . . .

Before we take a closer look at Thomas's reaction, we should consider the other characters Rembrandt included in the painting. Most unusual is the fellow in the bottom right corner who is fast asleep. The artist may have intended this character to represent the many who do not believe in spite of the body of convincing evidence. They are spiritually obdurate. In the story of the rich man and Lazarus, Jesus informs us that some people just will not believe, no matter who it is that brings them the news. "If they do not listen to Moses and the Prophets, they will not be convinced even if someone rises from the dead" (Luke 16:31). With spiritual eyes closed, some will not accept the truth even if it hits them square in the face.

The half-circle group to the right of Jesus, who have seen their risen Lord once before, still seem somewhat surprised. Having seen him once already, they are more prepared the second time around to get a closer look. One man stands from his chair, another leans over the shoulder of Christ to see the wound, others are kneeling, and another remains seated. This group may represent those who have seen the evidence, know the facts, and are working at integrating them into their belief system.

The threesome to the far left of the painting hesitate to get too close. Taken somewhat aback, they still want to know what is going on. They observe closely with full attention what transpires between Jesus and Thomas, all the while maintaining a safe distance. They remind us of those who stay on the edge, perennially hesitating to come to mature faith because they are forever mulling over the cost of committing to full belief.

One young man, placed just behind the slumbering character, resists looking directly at Christ. His folded hands and gaze turned sideways may indicate reverential awe and an approach of worship and humility. He dares not lift his eyes to look directly upon the miraculous and wounded body of the risen Christ. He believes without seeing. Rembrandt may have included this fellow as confirmation of John's recorded words of Jesus that those who have not seen and yet believe are blessed.

With which group or person in this painting do you identify? Why?

Trembling Fear

Now look again at Thomas. Fright has caused him to reel back in a knee-jerk attempt to distance himself from the reality that stands before him. This body was dead! Lifeless. Now it stands before him full of life, breathing, confronting, challenging his mind and convictions, beliefs and former defiance. Jesus is back! Thomas may not be so comfortable with this drastic turn of events. William H. Willimon, chaplain at Duke University, wrote in one sermon, "Isn't it interesting

If there is one thing we fear more than the death of God, it's the fear of a god who won't stay dead, who keeps following us, hounding us, coming back to us.

—William Willimon, "He's Back," p. 66.

ℰ𝒶

"Why am I a Christian?" I sometimes ask myself, and to be perfectly honest the reasons can be reduced to two: (1) the lack of good alternatives, and (2) Jesus. Brilliant, untamed, tender, creative, slippery, irreducible, paradoxically humble—Jesus stands up to scrutiny. He is who I want my God to be.

—Philip Yancey, *The Jesus I Never Knew,* p. 265.

that the predominant emotion on the first Easter was not joy? It was *fear.* . . . They were scared. Scared half out of their wits" ("He's Back," p. 66).

Mark tells us that the women who first discovered the tombstone moved and heard the angel tell them Jesus had risen fled, trembling and bewildered, and said nothing to anyone because they were so afraid (Mark 16:8). Running into a corpse come back to life is enough to scare anyone. However, their fear involved more than initial shock. If Jesus was really back, what radical implications might this have for their personal lives?

Through his paintings Rembrandt has presented a Jesus who brought change in people's lives, usually through unconventional means. He upended settled arrangements, challenged conventional judgment and practice, and dangerously questioned the status quo. He said stuff like, "Go, sell all you have and give to the poor," and, "Anyone who loves his father or mother more than me is not worthy of me," and, "If someone hits you on the right cheek, let him hit you on the left as well," and, "Forgiving someone who has wronged you seven times is not enough; it needs to be seventy times seven," and, "Pray for those who make life miserable for you, love those who can't stand you."

But then he died, in the way of all flesh. It would take a little while, but the dust would settle. Monday morning would come, people would go back to work, and by Wednesday, or at the latest Thursday, the world would be like it was again

before he showed up. Back to same old scene—not forgiving when wronged, retaliating when hit, loving family members and ourselves more than God, ignoring the poor or giving token help to the poor, unethical business deals, impoverished classes, broken homes, teen suicide, escalating crime, terrorism, chemical warfare, starvation, increasing gap between the rich and the poor, casual sex, teen prostitution, and genocide.

Then something happened. Jesus came back! He will not leave us alone. Not even death can stop him from continuing the change he initiated his first time here.

Earlier the disciples had said, "He's dead. Now what's to become of us?" After Easter, it was, "He's back! Now what's to become of us?" Now we can't live just any way we want. Jesus has no intention of leaving us for dead. He's not satisfied to leave his work undone, as some suspected of him, but returns to bring it to full completion—not content with starvation, teen suicide, unethical business practices, genocide and terrorism, casual sex, hating our enemy, living with a spirit of unforgiveness. . . . He's back, whether we like it or not. In a way it's quite scary.

———————————

That image of God "hounding" us, of refusing to give up, can be both comforting and dismaying. In what situations might you find it comforting? In what situations scary or dismaying? Why?

———————————

Certain Joy

Along with incredulous astonishment, Thomas's expression reflects joy—joy that is worth the scare. A relieved joy on the verge of moving from his senses to his heart. What he sees before him with his own eyes will soon register in his mind and bring to him the implications for his faith. Overwhelmed with uncontainable joy and still in a bit of a daze, he lets his confession spill out, "My Lord and my God!"

The resurrection of Jesus has established his lordship beyond doubt. He has won victory over the final enemy, claiming authority over the grave. He holds the keys of hell. Thomas testifies to Jesus' lordship and authority over his life. Jesus' will is singularly all-important to his disciple. "Where you go, Lord, I will follow, even unto death." Thomas is now free to let his earlier commitment to his Master have full reign. Free to live as Christ calls him to live, to be part of the renewing ministry Jesus initiated, and in the process, free to discover his true identity. In Jesus we discover what it means to be a real woman, a real man, a real person created in God's image. This is biblical joy— the certain joy that comes with living a life packed with divine purpose. The type of joy Jesus came to bring: "I have told you this so that my joy may be in you and that your joy may be complete" (John 15:11).

Thomas and we can make such a commitment to Jesus as Lord because we confess he is also God. This Jesus is God himself in the flesh. In him we see who the invisible God of the universe is. In him— his hands, his feet, his voice, his eyes, his heart—we experience nothing less than the very presence and glory of the God who created us and the universe we live in. In this Jesus we experience triumph over death.

All because of the risen, living Jesus.

Incredible Life

Knowing historical facts about Jesus, the man who lived two thousand years ago, is important to faith. But historical fact alone will not deal with doubt and cause belief. Neither will strictly logical argument or reason ultimately convince anyone to believe. Although Christian faith is reasonable, given the historical witness, it is not necessarily logical or provable in scientific terms. The dead do not come back to life according to natural law. To believe and not continually struggle with doubt requires much more than logic—it requires a relationship with Jesus. In the letter of Ephesians we read, "I pray that out of his glorious riches he may strengthen you with power through his Spirit in your inner being, so that Christ may dwell in your hearts through faith. And I pray that you, being rooted and established in love, may . . . grasp how wide and long and high and deep is the love of Christ, and to know this love that surpasses knowledge . . ." (Eph. 3:16-19). This love surpasses knowledge. The mind on its own cannot fully grasp or experience this love of Christ; it demands our

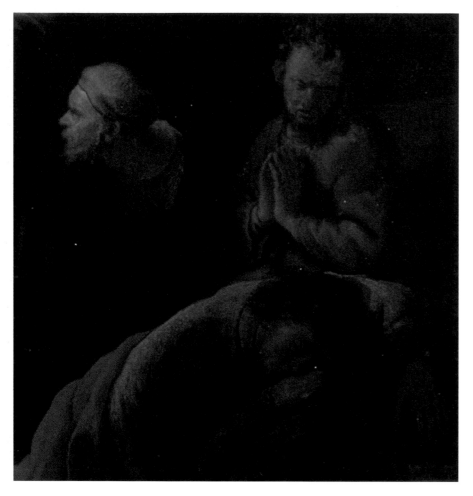

whole being—mind, emotions, heart, body, senses. In experiencing union with Jesus wholistically, we come to faith and grow in faith and find assurance in what we believe. The Christian faith is incredible, yet certainly believable when experienced in Christ.

The seriousness with which Rembrandt Van Rijn appreciated this truth can be seen in how he felt called to communicate the gospel visually, emotionally, and aesthetically through his art. God was far too big to be boxed in and understood merely with the mind. And words, whether written or spoken, had their limitations as well. Just as cooking a hare requires having the hare, believing in God entails having God. The artist realized that having God involves our whole person, so he painted his biblical vision of God expressed in Jesus to appeal to our senses. Not only with the eye but with the ear as well he engages our minds and our hearts to see Jesus as depicted in the written Word. I believe! I do so because I experience Jesus with my senses, my head, and my heart.

What role does the Holy Spirit play in our coming to faith? (See John 3:5-8.)

Sharing Life

Along the way Rembrandt teaches us something valuable about how to reach our world for Christ—how to communicate Jesus to others in a contemporary culture. His approach might be called an

aesthetic one, engaging the emotions, the senses, the intellect, and the heart. He communicates in a way that draws others into the life, ministry, death, and resurrection of God's Son. The artist challenges us to witness for Christ wholistically, appealing to all aspects of those we seek to reach.

The church, in its efforts to communicate Christ, has sought to draw a complete portrait of Jesus. How handy a neatly packaged portrait would be! Such ventures have consistently fallen short. The quest for the historical Jesus never comes to conclusion. The enigmatic Jesus escapes ultimate and final definition. The Bible contains four gospel accounts of Jesus' life and ministry. One in itself is unable to reveal the Son of God adequately—it always remains incomplete. Jesus refuses to be put into a mold. He eludes being defined by one individual's theological paradigm or harnessed to one person's biases.

Rembrandt, it seems, had a sense of this truth. His paintings of Christ differ so much from one to another that an unaware observer might not realize that the artist was painting the same character. This may be because Rembrandt had come to the conclusion in his spiritual journey that in Jesus we are confronted with an unfathomable mystery—and at the same time with the only One who gives ultimate significance to our life. It is this significance that Rembrandt sought to express over the course of his artistic career.

Jesus said to Thomas, once he had made his confession, "Because you have seen me, you have believed; blessed are those who have not seen and yet have believed" (John 20:29). We were not born in time to see Jesus in the flesh with our eyes, as Thomas and the other disciples were. Nonetheless, as children of God we have an innate, restless desire to "see Jesus," our brother, and to know God through him. My prayer has been that our reflections on the life and ministry of Jesus through the eyes of Rembrandt have helped our inner eye of faith to see Jesus with increased light, with deeper clarity, and with a heightened desire to follow him with purity of heart. This is the way of blessing. "Blessed are the pure in heart for they shall *see* God" (Matt. 5:8).

Look back over Rembrandt's works in this book. In what ways do these pictures proclaim the message "I believe!"?

Works Cited

Bell, Michael D. "Magic Time." *Atlantic Monthly,* December 1996.

Bhaumik, Subir, Ganguly Meenakshi, Tim McKirk. "Seeker of Souls." *Time,* September 15, 1997.

Bolton, J., H. Bolten-Rempt. *Rembrandt.* Danbury, Conn.: Masterworks Press, 1984.

Boyd, Malcolm. *Are You Running with Me, Jesus?* New York: Avon Books, 1965.

Buechner, Frederick. *Wishful Thinking.* New York: Harper and Row, 1973.

———. *Peculiar Treasures, A Biblical Who's Who.* San Francisco: Harper Collins, 1979.

Campolo, Anthony. *Exploring Faith and Discipleship.* Grand Rapids, Mich.: Christian Schools International, 1992.

———. "Love and Life in Edmonton," October 24, 1995, Kennedy Recordings.

Capon, Robert Farrer. *Parables of Judgment.* Grand Rapids, Mich.: Wm. B. Eerdmans, 1989.

Chapman, H. Perry. *Rembrandt's Self-Portraits.* Princeton, N. J.: Princeton University Press, 1990.

Clark, Kenneth. *An Introduction to Rembrandt.* New York: Harper and Row, 1978.

———. *Civilisation: A Personal View.* London: Jolly and Barber Limited, 1973.

De Moor, Robert. "Who Deserves the Kingdom?" *The Banner,* October 17, 1983.

Dostoyevsky, Fyodor. *The Brothers Karamazov.* Trans. Andrew MacAndrew. New York: Bantam Books, 1970.

———. *The Devils.* London: Penguin Books, 1953.

———. *The Letters of Fyodor Michailovitch Dostoyevsky to His Family and Friends.* Trans. Ethel Coburn Mayne. London: Peter Owen Publishers, 1962.

Donne, John. "Holy Sonnet 10." *The Norton Anthology of English Literature.* 6th ed. Ed. H. Abrams. New York: W.W. Norton and Co.

Galli, Mark. "Saint Nasty." *Christianity Today,* June 17, 1996.

Greene, Graham. *The Power and the Glory.* Middlesex: Penguin Books, 1962.

Guiness, Os. *God in the Dark.* Wheaton, Ill.: Crossway Books, 1996.

Haeger, Barbara Joan. *The Religious Significance of Rembrandt's Return of the Prodigal Son: An Examination of the Picture in the Context of the Visual and Iconographic Tradition.* Dissertation, University of Michigan. Ann Arbor: University Microfilm International, 1983.

Hanlyn, Paul. *The Life and Times of Rembrandt.* Feltham, Middlesex: The Hamlyn Publishing Group, 1968.

Hatch, Nathan. "The Gift of Brokenness." *Christianity Today,* November 14, 1994.

Johnson, Marilyn. "What Happens to Children Nobody Wants?" *Life Magazine,* May 1997.

Kuyper, Abraham. Adapted by James C. Schaap. *Near Unto God.* Grand Rapids, Mich.: CRC Publications and Wm. B. Eerdmans, 1997.

Lewis, C. S. *The Great Divorce.* Glasgow: William Collins Sons and Co. Ltd., 1946.

Mauriac, François. *The Knot of Vipers.* London: Eyre and Spottiswoode, 1932; English trans. 1951.

Moltmann, Jurgen. Trans. Margaret Kohl. *Jesus Christ for Today's World.* Minneapolis: Fortress Press, 1994.

Myers, Bernard. *The Book of Art: How to Look at Art.* New York: Grolier Inc., 1965.

Nouwen, Henri. "Reflections: Classic and Contemporary Excerpts."*Christianity Today,* November 11, 1996.

———. *The Return of the Prodigal Son.* New York: Doubleday, 1994.

Peterson, Eugene P. *The Message.* Colorado Springs: NavPress, 1993.

———. *The Message: Job.* Colorado Springs: NavPress, 1993.

Rand, Richard. *The Raising of Lazarus.* Los Angeles: Museum Associates at Los Angeles County Museum of Art, 1991.

Rollins, Wayne, G. *The Gospels, Portraits of Christ.* Philadelphia: Westminster Press, 1952.

Rose, Barbara. *The Golden Age of Dutch Painting.* New York: Frederick A. Praeger Publisher, 1969.

Rosenberg, Jakob, Seymour Slive, E. H. ter Kuile. *Dutch Art and Architecture, Pelican History of Art.* Middlesex: Penguin Books, Ltd., 1966.

Rosenblatt, Roger. "Beauty Dies." *Time Magazine,* September 8, 1997, p. 60.

Schwartz, Gary. *Rembrandt: His Life, His Paintings.* Middlesex: Viking Press, 1985.

———. *The Complete Etchings of Rembrant.* New York: Dover Publishing, Inc. 1988.

Seerveld, Calvin. "The Fall Demanded Christ's Sacrifice." *The Banner,* December 11, 1995.

Slive, Seymour. "Rembrandt." *The Worldbook Encyclopedia.* Chicago: World book, Inc., 1990.

Slofstra, Bert. "Have You Heard the Pop of the Cork Lately?" *The Living Word.* St. Catharines, Ont.: Synodical Committee for Sermons for Reading Services, Calvinist Contact Publishing Limited.

Smedes, Lewis B. *Forgive and Forget.* New York: Pocket Books, 1984.

———. *How Can It Be All Right When Everything Is All Wrong?* New York: Pocket Books, 1982.

Stott, John. *The Cross of Christ.* Downer's Grove, Ill.: InterVarsity Press, 1986.

Strobel, Lee. *What Jesus Would Say.* Grand Rapids, Mich.: Zondervan, 1994.

Thielicke, Helmut. *The Waiting Father.* San Francisco: Harper and Row, 1959.

Timmer, John. *The Kingdom Equation.* Grand Rapids, Mich.: CRC Publications, 1990.

VanderArk, Daniel R. "Self-Esteem." *Christian Home and School,* October 1996.

Wallace, Robert. *The World of Rembrandt.* New York: Time-Life Books, 1968.

White, Keith. *Masterpieces of the Bible.* Grand Rapids, Mich.: Baker Book House, 1997.

Williams, Margery. *The Velveteen Rabbit.* New York: Smithmark Publishers, 1995.

Willimon, William. "He's Back." *Best Sermons 4.* Ed. James W. Cox. San Francisco: Harper Collins, 1991.

———, Stanley Hauerwas. *Preaching to Strangers.* Louisville: Westminster/John Knox Press, 1992.

Wolterstorff, Nicholas. *Art in Action.* Grand Rapids, Mich.: Wm. B. Eerdmans, 1987.

Wright, N. T. "The New Improved Jesus." *Christianity Today,* September 13, 1993.

Yancey, Philip. *A Perfect Empty Shell Exploring Faith and Discipleship.* Grand Rapids, Mich.: Christian Schools International, 1992.

———. *The Jesus I Never Knew.* Grand Rapids, Mich.: Zondervan, 1995.

———. *What's So Amazing About Grace?* Grand Rapids, Mich.: Zondervan, 1997.